color

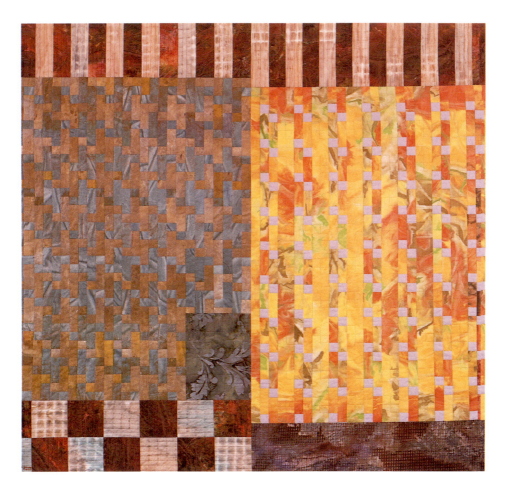

Michael James, *A Slight Resemblance*, 1997, machine-pieced and quilted, hand-painted and commercial cotton fabrics.

color

a workshop approach

David Hornung

McGraw
Graw
Hill

Boston Burr Ridge, IL Dubuuque, IA Madison, WI New York San Francisco St. Louis
Bangkok Bogotá Caracas Kuala Lumpur Lisbon London Madrid Mexico City Milan
Montreal New Delhi Santiago Seoul Singapore Taipei Toronto

Color: A Workshop Approach

Published by McGraw-Hill, an imprint of The McGraw-Hill Companies, Inc. 1221 Avenue of the Americas, New York, NY 10020.

Printed in Singapore

1 2 3 4 5 6 7 8 9 0 3 2 1 0 9 8 7 6 5 4

ISBN 0-07-302305-1

Editor-In-Chief: Emily Barrosse
Publisher: Lyn Uhl
Senior Sponsoring Editor: Joe Hanson
Editorial Assistant: Elizabeth Sigal
Marketing Manager: Lisa Berry
Media Producer: Shannon Gattens

A CIP catalog record for this book is available from the Library of Congress.

This book was produced by
Laurence King Publishing Ltd, London
www.laurenceking.co.uk

Editor: Robert Shore
Designer: David Hornung
Picture Researcher: Sally Nicholls

Frontispiece: Michael James, *A Slight Resemblance*, 1997

CONTENTS

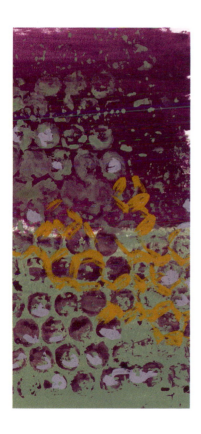

FOREWORD

One would think that a condition of the physical world as omnipresent as color would be easy to understand. Because it is a function of light, however, and because light is highly variable, color is one of the most elusive and enigmatic elements for the artist and designer to master. That it is also a cultural construct, and reflective of psychological, sociological, and even political developments, complicates the subject even further.

David Hornung has brought his long experience as a visual artist to the task of demystifying the phenomenon we call color and making it accessible to the art and design student. He wisely avoids the tendency of color theorists to systematize color and opts for a hands-on experience that is both practical and logical. He recognizes from his own studio career that colorists don't spring to life with some fully formed capacity to compose color and to communicate with it. Rather, they develop confidence in working expressively with color through a dedicated and disciplined practice experienced at the tip of a brush or pen or pencil, through cut or torn collage elements, or via pixelated images on a computer monitor.

Color language is quite specific and efficient, and Hornung is careful to define and to illustrate the terms we commonly use to describe characteristics or aspects of color and color usage. From semantic misunderstandings or misreadings arise many of the problems associated with color study, but here the student will find a rigorous yet streamlined analysis of that language designed to avoid just such misinterpretations.

I have been fortunate on a number of occasions to visit David Hornung's color classes at Rhode Island School of Design, to sit in on critiques of student work, and to look closely at student portfolios from those classes. One of the many strengths of his pedagogical approach is that it is flexible enough to allow for, in fact to encourage, exploration through a broad range of visual structures. This democratic sensibility makes the work comfortable for students in widely varying disciplines. The experience of color that each student engages in through the exercises documented in this course of study provides a solid grounding for professional activity in all visual fields. The impressive collection of examples of student work used here to illustrate each concept and each exercise in the sequence is evidence of the effectiveness of Hornung's vision as an educator.

This book will serve as both a manual of self-guided study as well as a handbook for directed study under the guidance and oversight of an experienced artist, designer, or art educator. As such it deserves a place alongside the classics of color literature such as Albers' *Interaction of Color* and Itten's *The Art of Color*. Its clarity, accessibility, and practicality make it an ideal complement to those universally respected studies.

Michael James
Ardis James Professor of Textiles, Clothing and Design
University of Nebraska at Lincoln, Nebraska

INTRODUCTION

We see color whenever we open our eyes in a lighted space, and color contrast makes things visible. We perceive qualities like roundness, relative distance, and texture through the brain's unconscious and instantaneous decoding of myriad patches of color. Moreover, these patches are only discernible because of the eye's amazing ability to segregate specific frequencies of reflected light waves into comprehensible color sensations.

In art and design, color exerts a mysterious influence on the human psyche. It moves the viewer directly and effortlessly, like a natural occurrence. But anyone who has ever struggled over color choices knows otherwise.

This book is meant to function as a "workshop" in which one can participate by reading about color principles and then exploring them in a sequence of assignments. These color studies have been tried and tested over a twelve-year period at the Rhode Island School of Design with graphic designers, painters, textile designers, illustrators, and weavers. Over the years these assignments have been carefully refined so that each contains a distinct color lesson that nonetheless builds upon the lessons that precede it.

Participation in the workshop results in an ensemble of studies that can be kept as a reference for the student to revisit and even add to after the course is completed. The "free study" component, a self-directed activity that follows each formal assignment, can be extended indefinitely. Students have made as many as a hundred of them during the course.

Format and Processes for Color Studies

In order to make it possible to produce the needed number of studies in the space of one semester, we work within a standardized format. All studies are done in gouache and are under 40 square inches (258 sq cm) in size. A typical size is 6 x 6 or 7 x 5 inches (15.2 x 15.2 or 17.8 x 12.7 cm), usually mounted on an 8.5 x 11 inch (21.6 x 27.9 cm) card stock or 9 x 12 inch (22.9 x 30.5 cm) two-ply Bristol board. The small size of these studies allows students to complete many of them without investing too much time or energy in any individual image. The size

consistency and rigidity of the mounting board make the portfolio easy to carry, sort through, and store.

Gouache is the medium of choice for several reasons. First, it transcends categorical boundaries because it has uses in textile design, illustration, traditional graphic design, and painting. Students from different disciplines find it familiar or easy to adjust to.

Second, the colors dry rapidly to a consistent, matte surface that emphasizes their graphic qualities. Other media (e.g., acrylics, oils, alkyds, etc.) are inconsistent in opacity, qualities of application, drying times, and surface texture—irregularities that may enhance expressive range but that are impractical in focused color study.

Despite these few constraints, students enjoy considerable freedom in composition and technique. One of the most important aspects of the course is its flexibility in that regard. When students can explore color in a manner that is familiar to them, they are better able to absorb that which is new and unfamiliar.

Typically, students will approach color studies in a way that reflects their particular temperament. For example, some are most comfortable with indirect color application. They choose processes like collage, stamping, stenciling, or blotting which offer openings for improvisation. Others are drawn to direct painting. Among those, some prefer a loose, painterly touch while others employ the precision of hard-edged painting.

This book is illustrated, in large part, by the work of students in color classes at the Rhode Island School of Design. The credits at the end of the book acknowledge the creator of each example. Other illustrations, culled from examples of professional art and design past and present, demonstrate color use at the highest levels of accomplishment. A quick flick through these pages reveals the rich variety of visual possibility promoted by this course.

The Lesson Sequence

PART ONE (Seeing Color) explains the fundamentals of color perception. It discusses the concept of color overtones and the six "co-primaries" we use for expanded possibilities in color mixing.

PART TWO (First Principles) introduces and illustrates essential terms like hue, value, and saturation. (For quick reference there is an illustrated glossary at the back of the book.)

PART THREE (Beginning Color Studies) opens with a suggested materials list and describes the initial four assignments aimed at clarifying the distinctions between color parts. It ends by introducing the self-directed "free studies" that help students get comfortable with color principles and bring them into their own studio regimen.

PART FOUR (Color Interaction) explores successive and simultaneous contrasts, optical phenomena that affect the way colors appear in combination with each other. Assignment 5 examines color interaction.

PART FIVE (Applications) expands upon the skills and understanding developed in the previous sections. It introduces three color assignments: 6 (progression), 7 (transparency), and 8 (retinal studies). Each assignment puts color principles to use in ways that challenge the student's skill and understanding.

PART SIX (Color Unity) investigates principles of color unity and diversity in terms of the overall quality of inherent light exhibited by a group of colors. The assignments (9 through 12) examine the tension provided by color anomaly and offer strategies that insure varying degrees of cohesion in color groups.

PART SEVEN (Color Research) looks at how artists often rely on outside materials for color ideas. Assignments 13 and 14 introduce two methods for summarizing color source material. The chapter ends with a few hints on the discussion of color in works of art and design. Assignment 15 is an exercise in color description.

PART EIGHT (The Psychological Experience of Color) provides examples of how color can excite extravisual associations. Color can add special significance to the experience of visual art. The course's final assignment (16) explores the link between color and meaning.

PART NINE (Color Studies on the Computer) explores possible uses of digital media. In recent years my students have complemented their hand-made studies with parallel compositions made on the computer in Adobe Illustrator. Part Nine asserts the advantages of this program for color study and provides a detailed discussion of how colors are constructed on the software's color sliders. Eleven of the workshop's sixteen assignments are shown as executed digitally.

Digital color study cannot supplant the involvement of the hand. Mixing colors and making careful comparisons in reflected light is a seminal component in understanding color. But the computer has proven valuable in the reinforcement of understanding gained through hand work. And, for the many who will be designing exclusively on the computer, the translation of color principles into that realm is useful.

Completing the Course

The sixteen lessons presented in this workshop can be accomplished in sixteen weeks if students can spend approximately eight hours a week on their studies. If time is limited, some of the assignments will need to be abbreviated. Also, depending on need and interest, some might be taken out of sequence. For example, a painter might pass over the transparency assignment, while graphic designers might skip the retinal studies. *The first four assignments are indispensable to everything that follows and should always be included.*

For those who already have some facility with color, this workshop offers avenues of color exploration that will enhance that innate skill. Others, for whom color is not a strength, will find in this course the means to a better understanding and more confident use.

I. SEEING COLOR

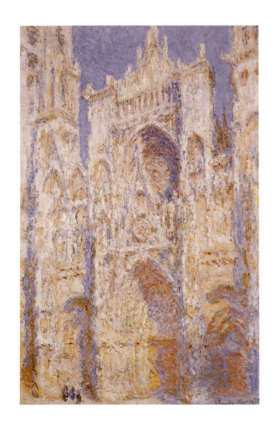 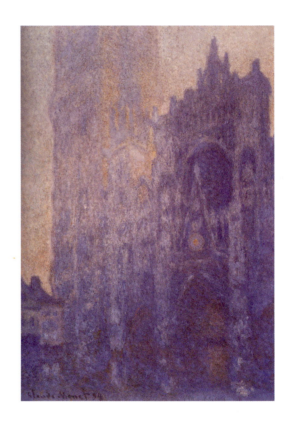

"Color is my day-long obsession, joy and torment."

Claude Monet

Color is said to be contained within light, but the perception of color actually takes place in the mind. As waves of light are received in the lens of the eye, they are interpreted by the brain as color.

Colors that seem similar (such as orange and yellow-orange) do so because their wavelengths are nearly the same. Wavelength in a ray of light can be measured on a nanometer:

red	orange	yellow	green	blue	violet
780–658 nm	658–600 nm	600–567 nm	567–524 nm	502–431 nm	431–390 nm

A ray of sunlight can be conceived of as being divided, like a rainbow, into a continuum of color zones. Each color zone contains more gradients than the mind can distinguish. The boundaries between colors are blurred, not sharply delineated. In the example below (fig. 1.3), the color yellow extends from the edge of yellow-orange on one side, across to where yellow merges into yellow-green on the other.

1.3 The full gamut of the the hue yellow extends from golden yellow (leaning toward orange) to lemon yellow (leaning toward green).

The perception of colored surfaces is caused by the reflection of light from those surfaces to the eye. A lemon appears "lemon yellow" to us because its molecules reflect light waves that pulsate at approximately 568 millimicrons while predominantly absorbing waves of other frequencies. Lightwaves that are not reflected are not perceived as color (as indicated in fig. 1.4).

Opposite Claude Monet made a series of twenty images depicting Rouen Cathedral at different times of day and under differing atmospheric conditions.

1.1 (left) Claude Monet, *Rouen Cathedral. West Façade, Sunlight,* 1894, oil on canvas, Chester Dale Collection, National Gallery of Art, Washington, D.C.
1.2 (right) Claude Monet, *Rouen Cathedral, the West Portal and the Tour d'Albane, Harmony in Blue,* 1894, oil on canvas, Musée d'Orsay, Paris.

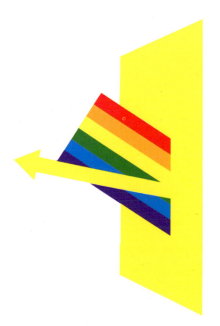

1.4 On a yellow surface, the yellow wavelengths are reflected while other colors are absorbed and are therefore not perceived.

Color sensation can also be caused by gazing, directly or indirectly, at colored light. When different colored lights are combined (as on a theater set), the combination adds luminosity or brightness. Hence, light intermixing is considered an ADDITIVE COLOR process.

In contrast to mixing colored light, the intermixture of spectral colors in pigment tends to produce colors that are duller and darker than those being combined. (Spectral colors are those that approach the purity of colors cast by a glass prism or seen in a rainbow.) The more unalike the pigments being mixed, the darker the result. Darkness means less LUMINOSITY, thus mixing pigments is a SUBTRACTIVE COLOR process.

Intermixing pigments darkens color because the reflection and absorption of color in pigment are never absolutely pure. Although lemon yellow, for example, does reflect the yellow part of the SPECTRUM, its absorption of other colors is not total (as suggested in fig. 1.12 on page 17). We see yellow predominantly, but subtle color reflections of all the other colors are also present. In the case of lemon yellow, a greenish cast is visible. (The diagram at right [fig. 1.5] gives a truer picture of light reflected from a lemon-yellow surface.)

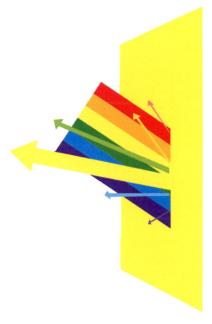

1.5 Color absorption in pigments is not total. Lemon yellow, for example, reflects visible amounts of green and smaller, less perceptible amounts of other colors.

COLOR OVERTONES AND THE PRIMARY TRIAD

Red, yellow, and blue form the PRIMARY TRIAD. When the full continuum of color (the spectrum) is represented as a wheel, the relative positions of red, yellow, and blue describe a perfect equilateral triangle (fig. 1.6). The simplicity and symmetry of the primary triad have a powerful appeal and, for some, an elemental significance.

While an infinite number of such triangles reside within the spectrum, the primary triad is unique because red, yellow, and blue are each, in theory, indivisible. They cannot be made by combining other colors. Conversely, all other colors can be made by combining two or more colors of the primary triad. But, as with our initial comments on color reflection, this is an oversimplification. Any color mixture also includes, along with the intended colors, their subsidiary color reflections.

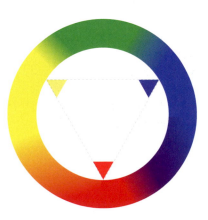

1.6 The primary triad forms an equilateral triangle on the spectral continuum.

The idea that one can mix all possible colors from the primary triad is based on the assumption that there are pure pigments that represent the true primary colors. Unfortunately, none really exists. All reds, yellows, and blues are biased, to a degree, toward one or another of the colors that adjoin them.

It is commonly understood that green can be mixed by combining blue with yellow. But to make a vivid, seemingly pure green would be impossible if the only blue available were ultramarine. An even duller green would result if the mixture were based upon a combination of ultramarine blue and golden yellow (fig. 1.7).

Both ultramarine blue and golden yellow are biased toward colors that contain red (violet and orange, respectively). Red lies opposite green on the COLOR WHEEL. Colors that oppose each other directly on the color wheel are called COMPLEMENTARY HUES. Mixing complementary colors lowers the SATURATION (richness) and VALUE (luminosity) of the resulting tone. In other words, it has a dulling and darkening effect. Mixing ultramarine blue and golden yellow adds a latent red (the subsidiary reflections of both colors) that dulls and darkens the resulting green (fig. 1.7).

To mix a vivid green, choose lemon yellow and sky blue (fig. 1.8). Both are biased toward green and reflect insignificant amounts of red.

In this course we call a color bias an OVERTONE, a term borrowed from music. When a C string is plucked on a harp or struck on the piano, the string vibrates at a specific rate that causes our ears to hear a C. But in addition to the C, we also hear a weaker vibration: a G and (more subtly) an E (fig. 1.9). In fact, a diminishing succession of subvibrations always accompanies the strong pitch of a plucked string. As when colors are mixed, when individual musical tones are combined, so are their overtones. The result is a denser sound than one might expect. Adding a third and fourth note thickens the harmonic texture. The role of color bias in mixing paint parallels this acoustical phenomenon.

1.7 The color overtones of ultramarine blue and golden yellow make it impossible to mix a vivid, spectral green from them.

1.8 When lemon yellow and sky blue are mixed, a vivid green can result because both are biased toward green.

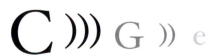

1.9 Each plucked note is accompanied by a series of subsidiary acoustical overtones.

Mixing a Secondary Triad

If we try to mix a vibrant SECONDARY TRIAD (orange, green, and violet) from a primary triad consisting of one specific red, one blue, and one yellow, some of the results will be compromised by conflicts in the colors' overtones. Consider a primary triad composed of scarlet (orange overtones), golden yellow (orange overtones), and ultramarine blue (violet overtones) as shown in fig. 1.10. A strong, clear orange would be possible because these particular reds and yellows both lean toward orange (fig. 1.11). But vivid violets and greens present a problem because the combinations necessary to create those colors contain overtones that conflict with the desired result. For pure violet, it's the right blue but the wrong red. For bright green, neither this blue nor this yellow is appropriate.

To overcome these limitations it might seem reasonable to create a primary triad by combining two versions of each primary color, each with a different bias. For example, by mixing sky blue (green overtones) with ultramarine blue (violet overtones), one can obtain a more neutral blue, one that has only the smallest discernible bias toward either green or violet. However, mixing secondary colors from such "neutral" primaries tends to split the difference, producing no mixtures that are ever quite lucid enough, but also none that is extremely dull. Truly vivid secondaries can only be achieved with primary colors that are *both* biased toward the target.

A CO-PRIMARY TRIAD

The most practical solution is to work from a primary triad consisting of six rather than three colors with two versions of each primary HUE. We call these six colors CO-PRIMARIES.

1.10 Intermixing these primaries (scarlet, golden yellow, and ultramarine blue)…

1.11 … produces these secondaries.

The co-primaries selected for this course are: crimson/scarlet (red), golden yellow/lemon yellow (yellow), and sky blue/ultramarine (blue). All six co-primaries are shown below (fig. 1.12) surrounded by their overtones.

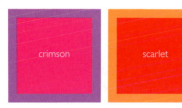 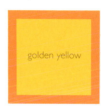 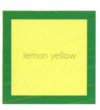 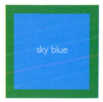 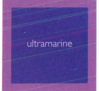

crimson scarlet golden yellow lemon yellow sky blue ultramarine

1.12 The six co-primaries, shown surrounded by their overtones.

The co-primaries used in this course can be intermixed to produce a full set of spectral colors and TONES derived from them. The addition of permanent white expands tonal possibilities further. But, even with co-primaries, there are still limitations. Some vivid secondary and tertiary colors, e.g., violet, will be unobtainable through intermixing.

Violets are mixed from the two darkest primary colors (blue and red). The results are often dark and difficult to read; when the goal is a "pure" violet, those obtained through mixing will always be a little disappointing.

Commercial violets, made directly from a violet pigment, are clearer than those made by color mixing. However, for consistency, it is better, in the first four studies in this course at least, to mix violets than to purchase them. The conceptual benefits gained by maintaining the palette's symmetry outweigh the richness of hue obtained by the addition of a commercial violet.

All the color for the studies in Part Two should be mixed solely from the six co-primaries plus white. As the course progresses, an EARTH TONE PRIMARY TRIAD (burnt sienna, yellow ocher, and blue-gray) should be added to the palette (fig. 1.13). Earth tones are easy to mix from the original co-primaries, but we suggest that you buy them premixed for economic reasons.

1.13 An earth tone primary triad:

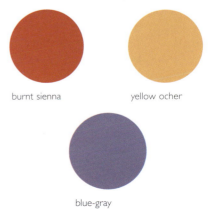

burnt sienna yellow ocher

blue-gray

THE INFLUENCE OF LIGHT ON REFLECTED COLOR

So far, our discussion of reflected light has been based on the effect of direct sunlight. In direct, relatively unfiltered sunlight, like that seen around noon on a cloudless day, the full spectrum of color frequencies is present, from infrared to ultraviolet.

At other times, such as early morning or late afternoon, particular colors are filtered out by the atmosphere. Variations in the color of light are evident in lighter colors (tans, light grays, yellows, etc.). Other atmospheric conditions like heavy cloud cover or pollution also limit the range of available light waves.

Artificial Light

Artificial light is sometimes called reduced spectrum lighting because it is deficient in some color frequencies found in sunlight. Incandescent bulbs, for example, yield a warm light that is strong in the yellow, orange, and red frequencies. On the other hand, fluorescent lighting tends toward the cool frequencies and casts illumination that favors blue and green.

Warm pigments will appear more vivid under incandescent lighting and somewhat deadened under fluorescent light. Cool colors, especially blues and greens, will appear livelier under fluorescent light.

For a clear demonstration of the hue bias of various light sources, carry a "white" piece of typing paper from a window to an incandescent lamp, and then to a fluorescent light. Examine the shifting temperature of the page as you move from one light source to another.

Theatrical Lighting

Dramatic extremes in lighting can have a profound effect on color perception. If squares of green and yellow (fig. 1.14) are lit by a strong blue light, the green is a rich blue-green, but the yellow appears black because its molecules reflect an imperceptible amount of the focused blue frequency. It is as if the yellow is not illuminated at all (fig. 1.15).

This is the essence of stage lighting, which can make the same set appear dramatically different by shifting the color of the light source to amplify or repress various colors on the set in concert with the narrative.

Standard Lighting

Today, most examples of two- and three-dimensional art and design are viewed under natural light, artificial gallery lighting, or reading light. Whatever the artificial light source, it is usually warm in temperature.

Package designs may be the exception since they are sometimes encountered under the relatively cool fluorescent lighting one finds in supermarkets and large pharmacies. (Although even fluorescent lighting has become warmer in recent years. There are fluorescent bulbs on the market that approach the warmth of incandescent lighting.)

Among designers, it is interior designers who are probably the most aware of the relationship between light, space, and surfaces. In their work, light itself becomes a design element.

We recommend that color studies made for this course be executed under light conditions similar to those in which they will be evaluated.

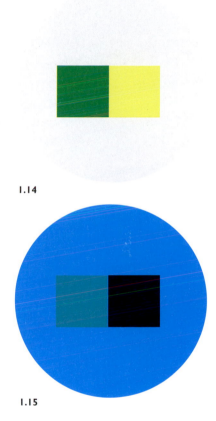

1.14

1.15

2. FIRST PRINCIPLES

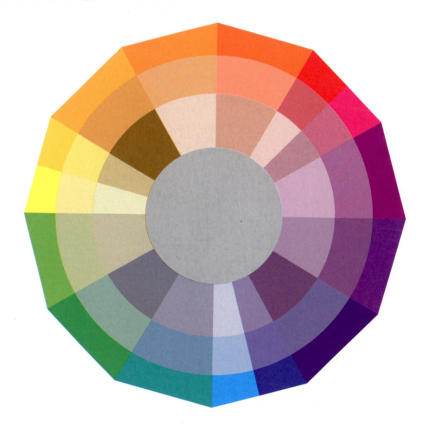

"Color theory is basically simple, not intricate. An elementary diagram, the symbol of an equilateral triangle, tells the fundamental story."

Faber Birren

ABOUT COLOR TERMINOLOGY

If you compared the glossaries of different color texts you would discover inconsistencies. For example, "brightness" is used to refer to both saturation and value. TERTIARY COLORS are those that lie exactly between each primary and secondary color on the spectrum, but some writers use the term to refer to colors of low saturation.

Inconsistencies notwithstanding, a few central terms have achieved broad if not universal acceptance and are consistently applied throughout the visual arts. The meanings of the words HUE, VALUE, and SATURATION are understood by anyone who regularly discusses color in their work. Other terms, such as TINT, SHADE, and ANALOGOUS HUES, are also common.

Where two or more terms are synonymous, we use the more descriptive one. Therefore, we prefer "saturation" to "intensity." In addition, we adopt several terms that are not widely acknowledged but that have proven useful in conversations about color. The terms CHROMATIC GRAY and MUTED COLOR, for example, answer the need to make categorical distinctions within the phenomenon of saturation. A glossary of color terms used in this course is provided at the back of the book, and each term featured in the glossary appears in capital letters when it first appears in the text.

THE STRUCTURE OF COLOR

Most people are aware that colors have more than one visible quality. In everyday language, color names, such as red, are often coupled with adjectives. Expressions like fiery red, cherry red, or blood red reflect an awareness that individual examples of colors have characteristics not adequately represented by a broad color name alone.

All colors have three distinct, fundamental parts that account for their appearance. Each of these parts can be manipulated independently either by color mixing or, more subtly, by altering the context in which the color appears. They are called hue, value, and saturation.

HUE

When we refer to a color by its name, we are referring to its hue. Color names correspond to particular zones on the color spectrum (fig. 2.1). There are thousands of color names; many have been created by the house-paint and cosmetics industries to lend specific identity to closely related tones. Artists and designers usually refer to colors by their pigments or by the names given to commercial artists' paints.

scarlet lemon yellow sky blue alizarin crimson

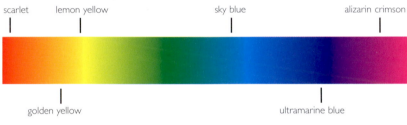

golden yellow ultramarine blue

2.1

Certain hue combinations have standard, categorical names. Typical of these color systems are: MONOCHROMATIC (one hue), ANALOGOUS HUES (colors adjacent to each other), COMPLEMENTARY HUES (based on a pair of opposites), and TRIADIC HUES (any three equidistant colors on the color spectrum when it is configured as a circle of hues).

Traditionally color schemes have evolved to simplify the problem of color harmony and to provide a guideline for the discussion of color in art and design. But as a formula for color harmony, traditional color schemes are too simplistic because they focus exclusively on hue. Color relationships should be assessed by other factors, such as proportional relationships in value and saturation, and how colors are distributed throughout a composition. The color of the quilt shown at right (fig. 2.2) is unified, not by a recognizable color scheme but a consistent lightness in color.

Describing the overall configuration, or range, of hues in a particular image makes us more conscious of what we see. The range of hue, value, or saturation in a piece of art or design can be described as broad, medium, or narrow.

2.2 Evelyn Derr or M.B.K. (attrib.), *Sampler Block Quilt*, July 1905, Smithsonian American Art Museum, Washington, D.C.

By way of analogy, consider the piano keyboard. To say a range of notes is broad implies that some notes are being struck in the highest and lowest octaves. It doesn't necessarily mean that there are *many* notes being struck. Likewise, a broad hue range draws color from diverse regions of the spectrum. For example, any triad of hues manifests a broad hue range because the three equidistant points of any triad imply the entire spectrum (fig. 2.3). A complementary pair also implies the full spectrum, even though only two hues are present (fig. 2.4).

The historic Peruvian textile shown below (fig. 2.5) is composed of the primary triad and therefore has a broad hue range.

Two examples of a broad hue range: a primary triad and a complementary pair.

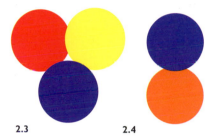

2.3 **2.4**

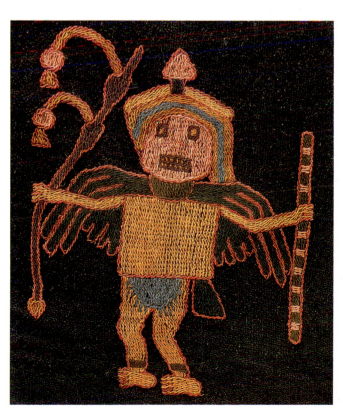

2.5 Maker unknown, *Paracas*, woolen fabric, National Archaeological Museum, Lima (detail shown).

The painting shown in fig. 2.6 by Philip Guston (1913–80) displays a medium range of analogous hues (reds and blues).

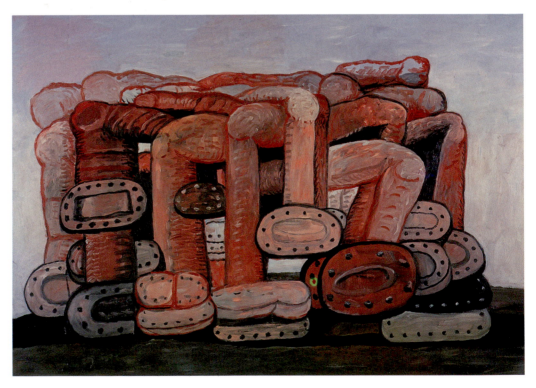

2.6 Philip Guston, *Monument*, 1976, oil on canvas, Tate, London.

A narrow hue range can be limited to closely related hues or monochromatic (variations of one color), as in the painting shown in fig. 2.7 by Mark Rothko (1903–70).

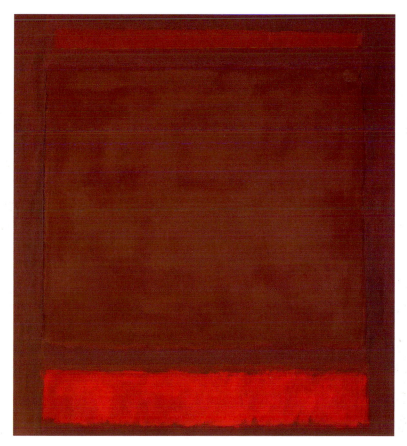

2.7 Mark Rothko, *No. 64*, 1960, oil on card, Collection of Kate Rothko Prizel.

Visualizing the Hue Continuum

The HUE CONTINUUM contains an infinite number of hues. It is therefore an unwieldy model for visualization (fig. 2.8).

2.8

A more useful representation of the full gamut of hues is a chart showing the primary and secondary triads as they relate to each other in the spectrum. This configuration encompasses the entire spectrum and provides a simple overview from which one can easily conceive of a variety of hue combinations (fig. 2.9).

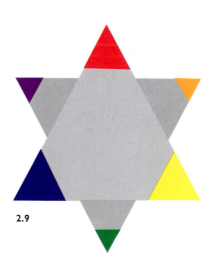

2.9

VALUE

VALUE signifies the relative luminosity of a color. Each of the three colored squares shown here manifests a distinct value (fig. 2.10). The gray squares beside them match their value (but lack the qualities of hue and saturation).

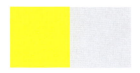

2.10

Black and white photography eliminates hue and saturation, leaving only value. Two versions of a painting by David Hockney are shown below (fig. 2.11). In the version on the right only the values of the colors are visible.

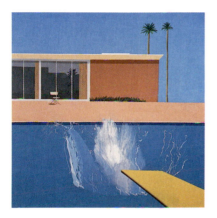 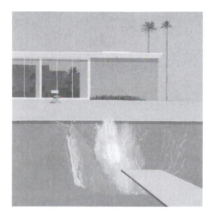

2.11 David Hockney, *A Bigger Splash*, 1967, acrylic on canvas, Tate, London.

Visualizing the Value Continuum

As with the hue continuum, the VALUE CONTINUUM contains infinite values (fig. 2.12). The full gamut of values is often simplified into a graduated scale called a GRAYSCALE. The grayscale shown below (fig. 2.13) consists of eleven steps ranging from black to white in even, progressive increments.

2.12

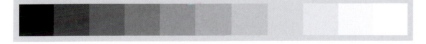

2.13

A simpler way to visualize the value gamut is with a three-part version of the grayscale (fig. 2.14). Any color can be placed approximately in a dark, middle, or light value category.

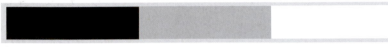

2.14

The range of values in art and design, like that of hues, can extend from narrow to broad. Below (figs. 2.15–16) the Guston and Rothko paintings from pages 24–25 are shown in grayscale. Compare their value ranges.

2.15 Philip Guston, *Monument*: broad value range.

2.16 Mark Rothko, *No. 64*: narrow value range.

SATURATION

Saturation refers to the relative purity of a color. The more a color resembles the clear, fully lighted quality of colors reflected in a prism, the more saturated it is said to be. In practice, it can be hard to identify saturation. The more luminous of two colors is not necessarily the more saturated, as demonstrated at right. In fig. 2.17 the color that is lighter in value (a pale yellow) is *less* saturated than its green neighbor. In fig. 2.18 the opposite is true: the lighter color (yellow) is also the *more* saturated of the pair.

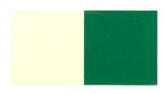

2.17

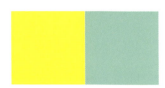

2.18

It is difficult for the inexperienced colorist to distinguish value from saturation. To do so, one must learn to perceive the difference between luminosity and purity in color.

Luminosity refers to value. The lighter a color, the greater is the reflection of the light source back to the eye. Lighter colors are therefore more luminous than darker colors. In fig. 2.19, primary hues are matched with their values. Of the three, yellow is the most luminous, but all are equally pure.

2.19

Visualizing the Saturation Continuum

Saturation is the measure of INHERENT LIGHT. While the relationship between value and actual light reflection is physically measurable, the connection between saturation and inherent light is immeasurable because it is essentially psychological in nature. The purer a color is, the more light it appears to have within it. On the saturation gamut seen below (fig. 2.20), inherent light decreases as it approaches the center. The colors at the ends of the scale (pure orange and blue) seem most illuminated from within.

2.20 The saturation continuum from orange to blue.

A SATURATION CONTINUUM of all levels of saturation would be created by mixing, in infinite degrees, any two fully saturated complementaries.

The relationship between color and light is one of the most powerful aspects of two-dimensional art. Light itself has a mysterious psychological effect. To see light appear to emanate from within a group of colors is an arresting visual experience.

Luminosity and inherent light are related to each other in individual colors and in color combinations. The presence of hue in a color is easier to read in lighter than in darker colors. At right (fig. 2.21) a cool dark square is surrounded by a field of light green. In this setting its blueness is harder to see than its darkness.

In fig. 2.22, the same dark blue is surrounded by black. Here, the lack of value contrast and the absence of hue in the black background makes the blueness of the small square more evident. The dark blue appears to have more inherent light in this setting. Thus, context can either compromise or enhance the sensation of inherent light in a color.

In figs. 2.23–24 the same prismatic red shows two different qualities of light. While the red in fig. 2.23 appears highly saturated, in fig. 2.24 it seems to glow from within.

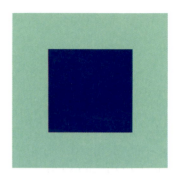

2.21

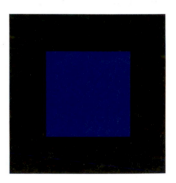

2.22

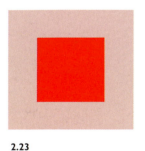 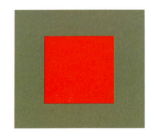

2.23 **2.24**

A pink square shown in three different settings (figs. 2.25–27) manifests three distinct qualities of inherent light.

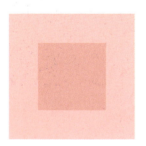 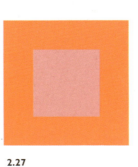

2.25 **2.26** **2.27**

The Four Levels of Saturation

We recognize four categories of saturation:

PRISMATIC COLORS are as pure in hue as is possible with pigments. Once a pure color has been altered through color mixing, it ceases to be prismatic (except when the admixture is a closely related hue, as when mixing yellow-orange into yellow).

MUTED COLORS range from rich colors that lie just outside the prismatic zone, to the most saturated chromatic grays. One can create muted colors by adding black, white, or gray to a prismatic color. Adding the complement of a hue will also diminish its saturation and produce muted color.

CHROMATIC GRAYS exhibit a subtle, yet discernible hue. Except for the proportions involved, they are mixed in exactly the same manner as muted colors. Chromatic grays simply require larger quantities of black, white, gray, or the complement.

ACHROMATIC GRAYS compose the inner circle of the color wheel. Grays mixed from black and white are achromatic because, like black and white, they lack perceptible hue and saturation. Achromatic grays can also be produced by precisely intermixing two complementary colors so that each hue cancels the other out. Insofar as a gray registers the slightest amount of perceptible hue it should be considered a chromatic gray.

2.28 The saturation scale shown below indicates the stages of saturation obtained by intermixing two complements: in this case, orange and blue.

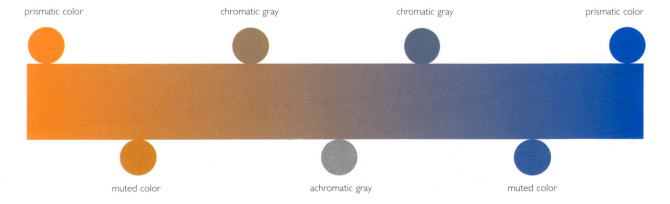

prismatic color chromatic gray chromatic gray prismatic color

muted color achromatic gray muted color

To visualize the levels of saturation, we use a color wheel that shows twelve major hues divided into steps emanating outward from achromatic gray at the center (fig. 2.29). Notice that the primary colors are subdivided into co-primaries. As you look across the wheel's diameter from any hue to its complement, the sequence of saturation from the outside in is: prismatic color ⟶ muted color ⟶ chromatic gray ⟶ achromatic gray ⟶ chromatic gray ⟶ muted color ⟶ prismatic color (as in the saturation scale on page 31).

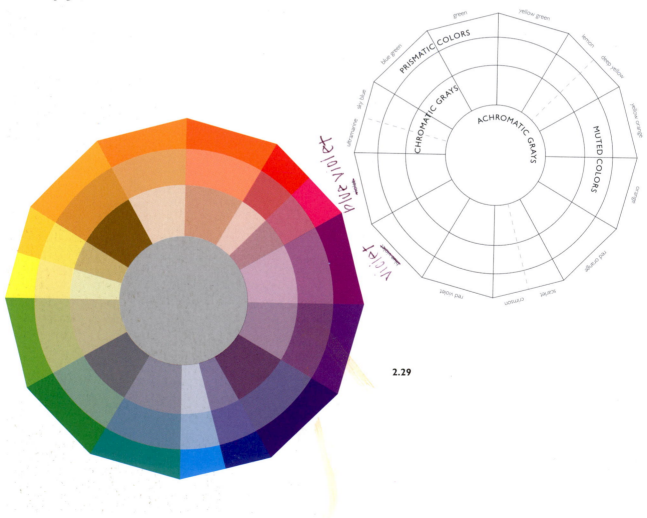

2.29

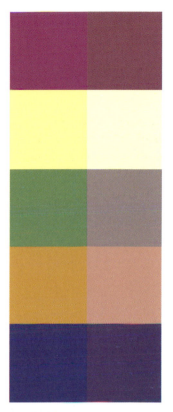

Muted color and chromatic gray are relative categories. Each consists of an infinite number of tonal variations, and the line between them is ambiguous. Despite the ambiguity, however, a general agreement on the location of that line usually emerges after a brief period of practice and discussion. As with similar ambiguities in the arts (such as the difference between *piano* and *pianissimo* in music), the relative character of this distinction does not undermine its meaning or practicality. The idea of two separate categories of saturation residing between pure (prismatic) color and noncolor (achromatic grays, black, and white) is useful as long as one maintains a personal consistency in the discernment of these distinctions.

In fig. 2.30, five chromatic gray tones are aligned with five muted colors in the same hue and with similar value.

Saturation Range

The range of saturation in an image, like that of hue and value, can run from narrow to broad. The Chinese panel shown below (fig. 2.31) has a broad saturation range because it contains colors representing all three levels of saturation: prismatic colors, muted colors, and chromatic grays.

2.30

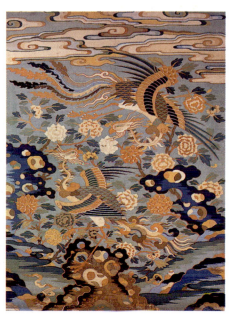

2.31 Maker unknown, *Feng Huang Panel*, Ming Dynasty, polychrome silk and gold, The Newark Museum, Newark, N.J.

This lyrical illustration by Brian Cronin, on the other hand, is constrained to chromatic grays (fig. 2.32). The overall impression is of a simplified and softened naturalism. The colors are knit closely together by their restraint.

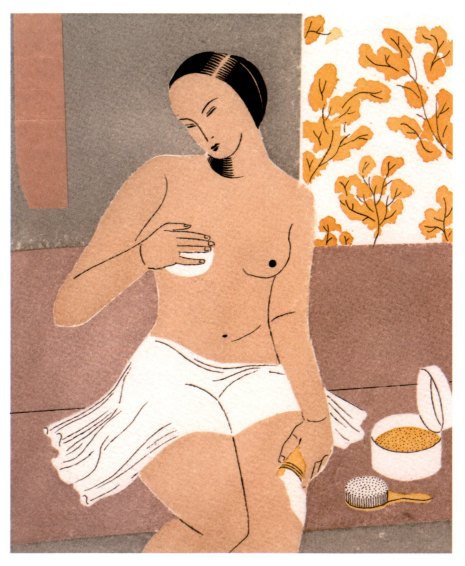

2.32 Brian Cronin, *Untitled*, 1992, india ink and acrylic on watercolor paper.

Manipulating Contrast in Hue, Value, and Saturation

Hue, value, and saturation are discrete aspects of color and can be manipulated independently. In the process of making art or design, one sometimes needs to adjust one part of a color without disturbing its other characteristics. For example, a shift in value might be required without any change in hue or saturation, or the hue of a color might need to be more precisely aligned with its neighbor without altering its value or saturation.

The pair of squares shown in fig. 2.33 are similar in value and hue, but the square on top is the more saturated of the two.

In fig. 2.34 the saturation relationship of the color pair is similar to that of fig. 2.33, but in fig. 2.34 the hue of the top square has shifted toward orange.

The two green squares in fig. 2.35 are similar in saturation but the one at the top is clearly lighter in value.

In fig. 2.36 the value relationship of fig. 2.35 is maintained, but the saturation of the lighter green is elevated to a nearly prismatic level.

It is also possible to diminish a color's saturation while maintaining its hue and value, as shown in fig. 2.37, or simply to lighten value while sustaining hue identity and saturation level, as in fig. 2.38.

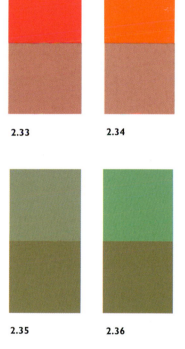

2.33 2.34

2.35 2.36

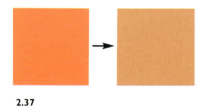

2.37

2.38

Inherent Limitations to the Independence of Color Parts

The independence of color parts is limited in certain circumstances. For example, when they are fully saturated, yellows are always light in value. The value of any yellow can be raised only marginally before it becomes white. On the other hand, darkening a yellow either by adding black or its complement will speedily diminish its saturation. (Yellow pigments tend to be weak and are consequently easily overpowered in mixtures by darker, more concentrated colors.)

Violet, too, is a special case. In its purest state it is the darkest of prismatic hues. As with other hues, adding white lowers its saturation and can produce muted colors or chromatic grays. But darkening violet (by adding its complement or black) makes it descend quickly to chromatic gray. It is difficult to create a muted color in violet that is significantly darker than its prismatic version.

Describing Color

Using words to describe what we see rivets our attention to visual phenomena in a way that casual looking seldom does. Of course, it is impossible to describe any color with absolute precision, but by focusing on contrasts of hue, value, and saturation we can discuss color with some clarity.

Here is a little classroom game to test both the understanding of basic terminology and mixing skill:

A student receives a small patch of painted paper containing one color. Without showing it to anyone, she or he describes the color using only the terminology introduced in this chapter; no other references are allowed. Guided by that description, another student attempts to mix the color. The result is then compared with the original.

Envisioning Light in Terms of Saturation

Imagine a small room containing only a single table covered with a white tablecloth. On top of the table rests a pure blue bowl. In the bowl are a bright red apple and a ripe yellow banana. The room is softly illuminated by a single light bulb controlled by a dimmer switch set at its lowest level. The lighting is so low that one can barely make out the distinctions between the blueness of the bowl, the redness of the apple, and the yellowness of the banana. In this low light the local colors of these three objects appear as chromatic grays. All the colors in view are kept at this weak level of saturation by the uniformly dim light that engulfs them.

Raise the dimmer switch a little and the distinct hues become clearer. But the room is still somewhat dark, and the red, yellow, and blue are softly muted. At this level of illumination the apple, banana, and bowl appear as muted colors. Bring the dimmer switch up to full light, and the fruit and bowl become nearly prismatic in saturation.

Now imagine that the dimmer switch in our room is set very low so that everything in sight is enveloped in semi-darkness. Only one small spot on the apple is illuminated by a distant source of light. Although the lighted area of the apple is only at the level of a muted color, it glows against the surrounding grays. Fig. 2.39 illustrates this point. In the center of the painting is a spot of concentrated light where muted colors are surrounded by more subdued tones of the same hue (chromatic grays). The red square at the center is a muted color, yet appears to be prismatic.

In two-dimensional art the sensation of inherent light depends largely on the readability of hue in a color. The most vibrant are prismatic colors; the subtlest are chromatic grays. When seen in isolation, prismatic colors are more "illuminated" than individual muted colors or chromatic grays, but it is not necessary to use prismatic color to achieve a sense of inherent light. When grouping colors, one should be responsive to their mutual interplay. Colors of slightly differing saturation can be skillfully arranged to make even chromatic grays seem to glow from within (fig. 2.40).

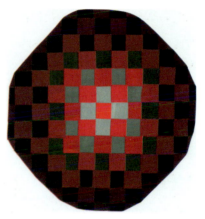

2.39

2.40 The skillful arrangement of hues among constrained value relationships gives each chromatic gray and muted color in this collage a lucid inner light.

THREE-DIMENSIONAL COLOR APPLICATIONS

This workshop focuses on the use of color in flatwork, but it would be an oversight not to discuss, in a general way at least, the application of color to three-dimensional objects. There are, of course, three-dimensional color treatments that extend beyond object-making. They can be grouped under the title "environmental arts" and include landscape architecture, set design, building design, and interior design. In these disciplines, color literally engulfs the viewer in the form of light, shadow, texture, pattern, and the special qualities of various materials. There is much to say about color with regard to these disciplines but we will confine our discussion here to color as it is applied to sculptural form.

Although two-dimensional art may have a textural component, the essential form of paintings, graphic designs, illustrations, and textile designs is flat, addressing the viewer frontally on a "two-dimensional" plane. Forms are evoked in the mind of the viewer through illusionistic devices.

In three-dimensional art, the problem of color and its relationship to the legibility of form is of central importance. The clear perception of three-dimensional form depends upon the combination of surface features, and the angle and intensity of the light in which it is seen. Renaissance marble sculptures, for example, are seen to best advantage when illuminated from above with sufficient brightness to cast shadows but not to the point where the surface detail within the shadows becomes obscured. Historic monochrome sculpture is thus most often displayed in this manner.

Contemporary·artists sometimes require their work to be illuminated from other angles, or with light that is either brighter or weaker than usual, or even with colored light. In these cases, the light itself plays a more assertive role and may become part of the content of the piece.

Given that light and shadow lend legibility to sculptural form, it stands to reason that pale, more reflective materials like marble, plaster, and light-colored woods express form more clearly than dark materials.

Sculpture that is multicolored can be difficult to read. But sometimes a level of perceptual confusion is intentional (fig. 2.41).

There are basically two distinct kinds of colored objects:

1. Forms that are made of colored material, e.g., sculpture, woven and knitted objects (rugs, sweaters, baskets, etc.), quilts and patchwork apparel, beadwork, and assemblage.

2. Forms that have had color applied to them, e.g., polychrome sculpture, and painted furniture.

Objects in the first category have a built-in unity of color and form, i.e., the physical structure of the object is necessarily at one with its coloristic variations. An example is fig. 2.42, in which Martin Puryear uses the inherent dark knots and sweeping streaks of reddish grain in pine wood to provide a lyrical counterpoint to the stark contours of his sculptural form. The wood's color is integral to the structure of the piece. Puryear's sculpture also demonstrates the way color variations, when they circumnavigate an object, emphasize its fullness as a form in space by leading the viewer from part to part.

2.41 (below left) Frank Stella, *Noris Ring*, 1982, mixed media on etched aluminum, Stella Collection.

2.42 (below right) Martin Puryear, *Sharp and Flat*, 1987, pine planking, Private Collection.

When color is applied to fully realized form, there is a risk of perceptual conflict. The artist should be sensitive to what color adds to or subtracts from the three-dimensional visual experience. A common solution is to paint the object a single color. This insures unity and can even reconcile, to a degree, unresolved relationships among forms.

Another approach, often seen in the decorative painting of architectural ornament and in polychromatic folk art, is to paint small forms within the whole a different hue or permutation of hue. The painted and carved wood panel (fig. 2.43) shows how this kind of color application clarifies the distinction between parts.

Perhaps most challenging from a coloristic point of view is to apply color in a kind of dialogue with form. Working in this way, the artist responds chromatically to each structural nuance. Applying coloring to a realized three-dimensional form can be difficult because, unlike with painting, one is never able to see the whole object at once.

Another consideration is the textural quality of both the form and the colored substance. Is the surface matte and powdery like plaster, or shiny like metal? The color too can be transparent or opaque, rough or smooth, glossy or matte. It can appear to be applied or seem to marry itself to the object's native material. The artist must decide how these characteristics affect the overall unity of the piece and its aesthetic quality.

Grace Wapner applies paint to her ceramic sculptures. The soft, matte quality of her surface treatment is compatible with the clay and allows the forms to breathe while adding a new level of information to the piece (fig. 2.44).

Found objects that were once painted but have endured the weathering of wind or water are often beautiful because the thing and its painted coating have been visually harmonized by the stress of existence. Nature and culture abound with time-altered detritus that can be studied profitably by colorists working in two or three dimensions.

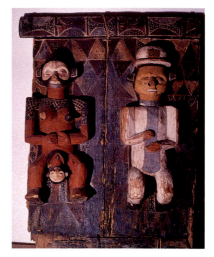

2.43 Yaka people, *Board*, 20th century, carved polychromed wood, Museum of Central Africa, Tervuren, Belgium.

2.44 Grace Wapner, *Scholars' Garden VI*, 2002, stained and painted ceramic, Collection of the Artist.

No artist has appreciated the subtle beauty of timeworn material more than Joseph Cornell (1903–72). Combining found objects with exquisite sensitivity, he imbued subtle color shifts and surface abrasions with a sense of memory and loss (fig. 2.45).

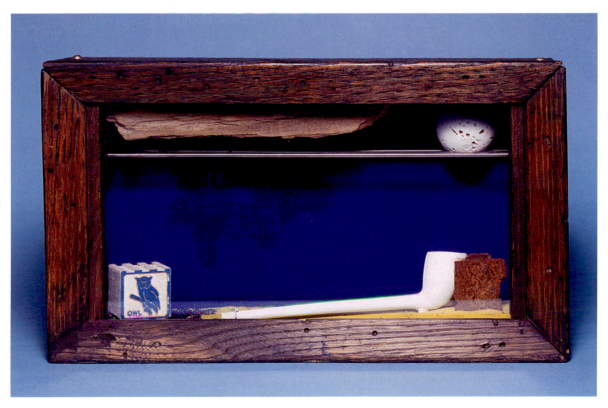

2.45 Joseph Cornell, *Soap Bubble Set*, 1945, mixed media, Private Collection.

3. BEGINNING COLOR STUDIES

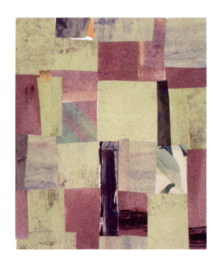

"And how important it is to know how to mix on the palette those colors which have no name and yet are the real foundation of everything."

Vincent van Gogh

WORKSHOP MATERIALS LIST

These are the materials you will need for this course of study:

Gouache:*
lemon yellow, golden yellow (co-primaries)
ultramarine blue (deep), sky blue
alizarin crimson, scarlet
burnt sienna, yellow ocher, and blue-gray (Payne's gray) (earth tone triad)
raw umber
large tube of permanent white (not zinc white)

9 x 12 inch (22.9 x 30.5 cm) two-ply vellum Bristol board (widely sold in tablets)
old newspapers or newsprint for painted paper collage
water container and paper towels
½ inch (1.25 cm) flat aquarelle brush with a beveled clear handle plus a soft "round" brush for color mixing
permanent glue stick
two small (2 oz.) plastic jars with screw tops for storing pre-mixed "darks"
ruler
scissors and a utility knife
pencil
roll of Scotch brand removable magic tape (3M item #811)
plastic cup palette (the best have six or more wells and a flat area for color mixing)
portfolio or box to contain finished work

* Gouache is a water-based paint that is very opaque and dries to an easily read matte finish. I recommend a professional-grade paint such as Winsor Newton or Lascaux. Less expensive brands usually have poor opacity and are difficult to work with. Acrylic is not a good alternative for this course.

You may want to substitute a similar color for one on the list. Prussian blue can replace sky blue, or carmine red can replace alizarin crimson, for example.

PREPARATION FOR PAINTED STUDIES

Before beginning the studies, you should mix two small containers of CHROMATIC DARKS. One should be warm and brownish, the other a cool dark blue-gray. These stock mixtures provide a ready-made dark tone of specific temperature that can be added to prismatic color alone, or with white, to produce muted colors and chromatic grays. Make these darks by mixing ultramarine blue and raw umber. (The warm dark will be more umber than blue and vice versa.)

Mix enough of the two chromatic darks for use in more than forty studies (about 1 oz. of each should be sufficient). When mixing this stock of warm and cool darks, you should test them occasionally for their visual temperature (warm or cold). To do so, make a tint by adding white to a small amount of the dark you are mixing and paint a patch on a piece of scrap paper (fig. 3.1). Tinting any dark color makes its inherent hue easier to see.

Store your pre-mixed darks in short (2 oz.) plastic jars with tight lids to prevent drying. Between painting sessions it is a good idea to keep the jars in a refrigerator.

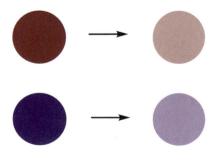

3.1 Adding a small amount of white reveals the inherent hue in a chromatic dark.

PRACTICAL GUIDELINES FOR THE STUDIES

A. In your color studies, work with planar abstraction or in a flat pictorial style. Feel free to apply paint in any manner (direct or indirect, hard-edged or painterly) but try to give your groups of studies a "family resemblance." It is important to keep the painting technique in any group of designs consistent, as in figs. 3.2–5.

3.2 3.3 3.4 3.5

B. Keep things simple. It is easy to get involved in an overly complicated image. In general, try not to spend more than an hour on any one study. Create compositions that demonstrate the principle at hand as eloquently as possible. You will find that practice makes you more efficient.

C. All studies throughout the course should be relatively small. Typical sizes are 6 x 7 or 6 x 6 inches (15.2 x 17.8 or 15.2 x 15.2 cm).

D. The white of the page should not be considered a color—the entire surface within each study should be covered with paint.

E. Paint studies directly on Bristol board or glue painted paper to a background painted directly on board.

F. Painted collage is an expedient technique to adopt for many of the studies, particularly the four introductory assignments in this part. Collage paper should be thin (newsprint works well) and burnished down on the Bristol board with the beveled handle of a brush or some other smooth, hard object. Use a cover sheet when burnishing to protect the collage's fragile paint surface. Because the studies are small, color patches created for

collages need only be about 4 x 4 inches (10 x 10 cm). Leftover painted paper scraps can be saved and organized. Any wet paint at the end of a session should be painted out on collage paper and reserved for use in future studies. Save color scraps in envelopes for easy access.

G. To define the perimeters of your backgrounds and to paint sharp edges, use removable cellophane tape (3M item #811) or a frisket. Wait for the paint to dry thoroughly before removing the tape.

H. Gouache painting takes a little practice. To prevent streaking, it is important that the water used in thinning be thoroughly mixed into the paint before use. Most of the time you will want flat, undifferentiated color, something akin to a silkscreen print in appearance. To this end, the paint should be stirred to the consistency of whole milk.

I. Dry your brush on a paper towel after each cleaning between colors. Ignore this seemingly trivial detail and you will soon find your color getting thinner and streakier. When you clean a brush, the water goes up into the metal sleeve that holds the hairs in place. That water, combined with whatever is left in the hairs of the brush after dipping, will go directly into the next color you use. Because the quantities of paint are small, the result of this oversight becomes visible almost immediately.

J. Closely examine the visual examples provided with each assignment and the digitally produced examples found in Part Nine.

The course begins with four pairs of studies exploring the three strata of saturation. The first set is made solely with chromatic grays. (Working within the quietude of gray promotes color sensitivity.) The second pair uses only muted colors, and the third, only prismatic colors. The fourth pair of studies contains a full range of saturation levels.

ASSIGNMENT 1

Chromatic Gray Studies

1A. Make a small gouache painting or painted-paper collage using at least six shapes not including the background color. All the colors in this study should be chromatic gray. Make the value range (the range of lights and darks) broad. Also try to include chromatic grays from a range of hues. No color should be used more than once.

Examples:

The study shown at right (fig. 3.6) explores a broad range of chromatic grays in both hue and value. All the tones in this study were made by mixing pure hues in very small amounts with premixed chromatic darks and white, or by adding complementary colors.

1B. Make a second study (a new design) the same size as the first also using only chromatic grays. This time, make a narrow value range with all the values congregating around the dark, middle, or light part of the value continuum (maintain a broad hue range).

Examples:

When the values of an image or design are predominantly dark, the image is said to be in a LOW KEY. This dark painting (fig. 3.7) is a good example.

An image is said to be in a HIGH KEY when its colors are limited to the light end of the value scale, as in fig. 3.8. Very pale colors tend to be chromatic grays. They have a weak hue presence and, consequently, little inherent light quality. (As noted earlier, yellow is the exception. Because it is light in value when fully saturated, prismatic yellow has both inherent light and luminosity.)

3.6

3.7

3.8

Giorgio Morandi (1890–1964) concentrated primarily on still-life painting throughout his career. His palette is characteristically subdued, consisting mostly of chromatic grays with an occasional touch of dull muted color. But he orchestrated the temperature of his grays intelligently to maximize their inherent light. In the painting shown below (fig. 3.9), Morandi makes effective use of minimal value contrast. The "dark" stripes on the "white" pitcher create a visual accent. So does the "orange" canister to its right.

In the detail of Morandi's painting in fig. 3.10, several circles have been superimposed to isolate specific color areas for easy comparison. At the

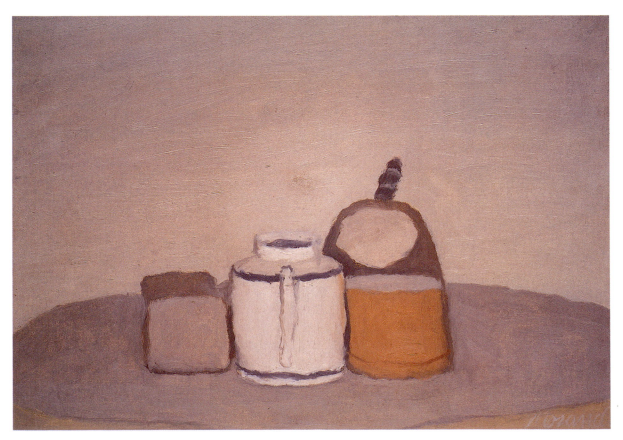

3.9 Giorgio Morandi, *Still Life*, 1949, oil on canvas, Museo Morandi, Bologna.

center of the black circle the color of the dark stripe on the white pitcher is displayed within a small ellipse (1). This shows that the darkest color in the painting is actually a mid-tone.

Similarly, a white circle (2) placed against what seems to be the white of the pitcher shows that the lightest value is not white at all, and only slightly darker than the "dark" stripe. In fact, the image of the pitcher contains a number of light chromatic tonalities ranging from blue-gray to orange-gray.

The orange tone is particularly interesting. It's the richest color in the picture, but comparison to a prismatic orange ellipse (3) shows it to be a rather weak muted color.

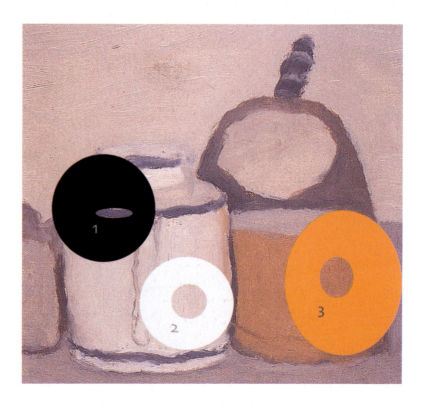

3.10 Detail of fig. 3.9.

ASSIGNMENT 2

Muted Color Studies

2A. Make a small painting or painted-paper collage using at least six shapes and with no repeated colors. Use only muted colors; the hue and value ranges should be broad.

Example:
Fig. 3.11

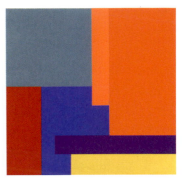

3.11

2B. Make another painting or painted-paper collage of the same dimensions in muted colors with a broad hue range and a narrow value range (as in 2A).

Examples:
The studies shown in figs. 3.12–13 are in a muted color with a narrow value range in a MIDDLE KEY. Both have a broad hue range.

Working with muted colors in a high key is essentially limited to yellows and their adjacent hues (fig. 3.14). Violet and its surrounding colors can never be light enough without dulling down to chromatic gray.

Conversely, in a low key of muted colors, yellow and its related hues cannot be darkened without losing a great deal of saturation. To produce a muted color image in a low key one must draw from the darker original hues, e.g., violet, blue, and green (fig. 3.15).

3.12

3.13

3.14

3.15

ASSIGNMENT 3

Prismatic Studies

3A. Make a small painting with at least six shapes using only prismatic colors. Make the value range broad.

Example:
Fig. 3.16

3B. Make another prismatic study with a narrow value range.

Examples:
Figs. 3.17–18

As with muted colors, the values of prismatic colors are determined by hue. But in the case of prismatic colors, the restrictions are even tighter. Yellows are always the lightest, violets the darkest. Consequently, in strictly prismatic color, the possibilities for working within specific keys are extremely limited. A prismatic study in a high key (fig. 3.17) must necessarily draw its hues from yellow and its close neighbors.

A low-key composition in prismatic color, as in fig. 3.18, must be derived from the violet part of the spectrum.

3.16

3.17

3.18

The mature work of Piet Mondrian (1872–1944) is almost always composed of prismatic red, yellow, blue, black, and "white." Within those limitations, he experimented with many different variations of the primary triad. He sometimes used light grays where one might expect pure white. In one of his final pictures, *Broadway Boogie Woogie* (fig. 3.19), Mondrian eliminated the black grid lines that had usually bound his colors. It is perhaps his most lyrical painting, and one in which the colored shapes seem animated. Notice the subtle variations in the very light chromatic grays.

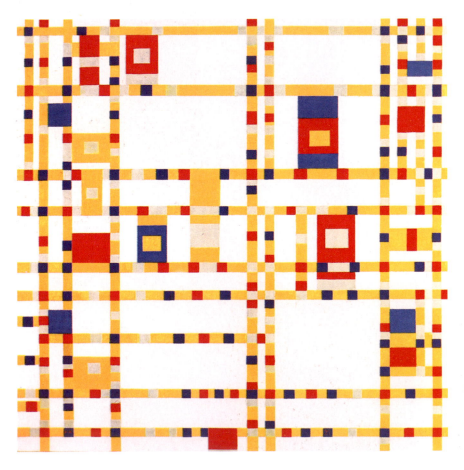

3.19 Piet Mondrian, *Broadway Boogie Woogie*, 1942–43, oil on canvas, 50 × 50 inches (127 × 127 cm), The Museum of Modern Art, New York, given anonymously. © 2004 Mondrian/Holtzman Trust c/o hcr@hcrinternational.com.

ASSIGNMENT 4

Combined Saturation Studies

4A. Make a small study with broad hue and value ranges. Use no fewer than six shapes and include colors from all saturation levels.

Examples:
In fig. 3.20 three levels of saturation appear in almost regular succession from left to right; fig. 3.21 is a more energetic treatment of the same assignment.

4B. Make a second study in a narrow value range with all saturation levels. Taking a broad range of saturation, you will find it easy to constrain the value of any hue.

Examples:
In both fig. 3.22 and fig. 3.23 the value range is narrow, but hue and saturation are broadly represented.

Rationale for assignments 1–4: It is important at the outset to get familiar with three distinct zones of saturation: prismatic color, muted color, and chromatic gray. These initial assignments are designed to strengthen your comprehension of these distinctions. They will also create familiarity with three parts of color (hue, value, and saturation) and their relationship to each other.

3.20

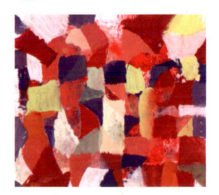

3.21

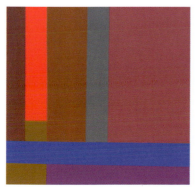

3.22

3.23

Most artworks combine several levels of saturation. This emotive little painting by Paul Klee (1879–1940) contains a full saturation range and a broad range of both values and hues (fig. 3.24).

3.24 Paul Klee, *Fire at Evening (Feuer Abends)*, 1929, oil on cardboard, The Museum of Modern Art, New York, Mr and Mrs. Joachim Jean Aberbach Fund.

Saturation and the Illusion of Space

The illusion of space in two-dimensional art is produced by visual clues like overlapping shapes, linear perspective, and relative size. With color, the sensation of spatial depth can be evoked by contrasts in saturation and color temperature. Sometimes a stark contrast in saturation alone is enough. In fig. 3.25, the prismatic red square in the center appears to float in front of a field of softer, duller versions of red and its adjacent hues.

When contrast of saturation is combined with that of temperature, the illusion of space in a picture or design is even more pronounced. Two versions of a gestural, abstract study, one in full color and the other in achromatic grays, appear below (figs. 3.26–27). Although the image is abstract, one can read space in and around the colored shapes in fig. 3.26. The depth of the background is established with cool chromatic grays while the most saturated colors hold the foreground. The achromatic version (fig. 3.27) appears flatter because it lacks contrast in both temperature and saturation.

3.25

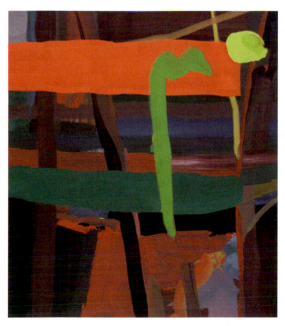

3.26

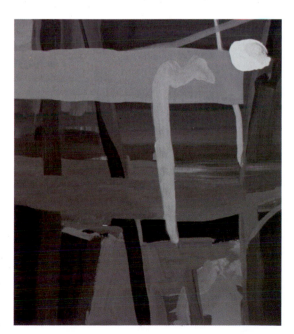

3.27

At right is an industrial landscape rendered from observation (fig. 3.28). The artist has transcribed the color literally, that is, she has not organized the saturation levels in the painting in a way that would illustrate what she *knows* about the depth of field in the scene. Consequently, the space in the painting appears somewhat flattened, like that of a photograph. (Highly saturated colors are often seen in the backgrounds of color photographs. The camera records a scene mechanically and doesn't organize color temperature or saturation to enhance spatial illusion.)

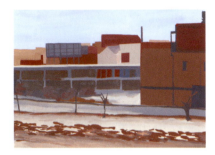

3.28

In the second version of this picture (fig. 3.29), the colors in the background have been made cooler in temperature, and the foreground colors are more saturated than the corresponding tones in fig. 3.28. The result is a clearer separation between background and foreground. Cool hues (from the blue/violet side of the color wheel) tend to pull away into the distance while warm hues (the orange/yellow side of the wheel) push into the foreground.

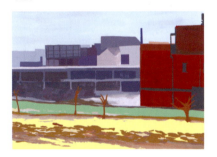

3.29

Does spatial clarity necessarily make for better art and design? In the Renaissance tradition, line, color, and size relationships are usually marshaled together to support the illusion of space within a picture. This requires an understanding of the way all spatial signifiers interact.

In the twentieth century, due in part to a broad awareness of pictorial traditions from outside of Europe, the construction of illusionistic space came to be considered a flexible and expressive variable. Modern painters in many idioms have deliberately opposed one illusionistic convention with another in the same image. The result evokes a feeling of tension within the visual structure of the painting that the artist Hans Hoffmann called "push-pull." In short, color can be used consistently with other formal elements to assert the illusion of space or it can provoke anxiety through discord with other spatial signifiers. One pictorial ambition should not be considered more inherently correct than any other. Quality is measured by the character of an artist's vision and the persuasiveness of her or his skill.

FREE STUDIES

As a complement to the assigned exercises, we conduct self-directed color experiments called free studies throughout the course. Except for a few general guidelines, these studies are designed by the student. They offer an opportunity to explore color concepts as they are introduced in a manner sympathetic to one's own temperament. Each regular assignment should be followed by a group of three to six free studies.

3.30

Guidelines for Free Studies

A. As with the other studies, paint them in gouache. But in free studies, the paint application can be more irregular in surface quality and opacity.

B. Do not exceed 8 x 10 inches (20.3 x 25.4 cm) in any study.

C. Free studies can be tied to particular color principles or investigate color in a more general way.

D. Experiment with process. Free studies can be painted in a variety of manners. Stenciling, collage, photomontage, stamping, rubbing, blotting, taping, scraping, stippling, tearing, cutting, or direct painting can all be emphasized.

3.31

E. Just as in the regular assignments, any group of free studies should be visually cohesive. Think of them as a "family" of images related to each other by a particular technique (rubber stamping, for example), a specific format (such as dots arranged in a grid), or by some other means. Maintaining continuity within a group of compositions tends to make color variation clearly visible (see figs. 3.32–50).

Examples:
Fig. 3.30 is a collage that combines painted paper with map fragments.
Fig. 3.31 employs a dribbling technique to apply paint.
Fig. 3.32 shows atmospheric effects achieved by blotting and applying paint with a brayer.

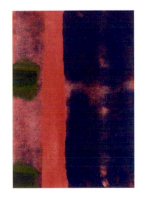

3.32

A few years ago, a graphic-design student found some wooden type at a yard sale. He created a large number of gouache studies using the type repeatedly as a formal element (figs. 3.33–34).

Another student, a textile designer, collected sheets of newsprint used in cleaning silkscreens in the textile lab and constructed two whole books of grid-based collages from them. Four of these are shown below (figs. 3.35–38).

3.33 3.34

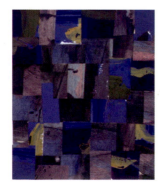

3.35 3.36 3.37 3.38

Here (figs. 3.39–42), solid colors are combined with colored photo fragments.

3.39

3.40

3.41

3.42

These distinctive gestural studies (figs. 3.43–46) are all freely painted with a vigor reminiscent of Abstract Expressionism.

3.43

3.44

3.45

3.46

These studies (figs. 3.47–50) are made from rubberstamps cut by the student. They demonstrate an inventive use of overlay and repetition.

3.47

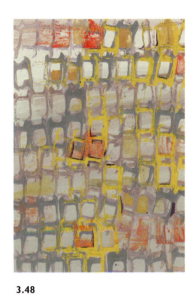

3.48

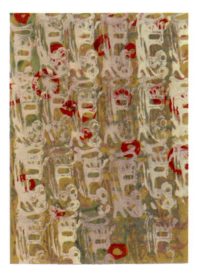

3.49

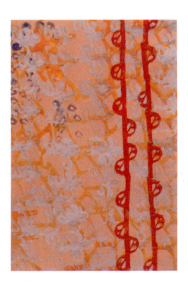

3.50

4. COLOR INTERACTION

"In visual perception a color is almost never seen as it really is—as it physically is. This fact makes color the most relative medium in art."

Josef Albers

AFTERIMAGES

Painters commonly experience the surprise of carefully mixing a color on the palette only to see it change when it is placed among other colors in a painting. The appearance of a color is affected by its neighbors, sometimes subtly, sometimes dramatically. This is caused by an aspect of vision that makes a halo effect called an AFTERIMAGE appear to surround individual shapes of colors and noncolors (black, white, and achromatic grays). We are not normally conscious of this phenomenon, but it is present wherever one shape meets another on a flat surface. In fact, despite our lack of awareness of them, the cumulative effect of multiple afterimages in a painting or a design enriches our visual experience.

The following experiments require visual concentration. To begin, stare at the black circle (fig. 4.1) for about twenty seconds, and then shift your gaze to the white area within the box below the circle (fig. 4.2). The afterimage will appear as a very bright white circle of the same size as the black one. This optical phenomenon is called SUCCESSIVE CONTRAST.

Now stare at the black circle again. Repeat the original action but, this time, when you see the circular white afterimage, concentrate on its outer edge. The afterimage will itself be surrounded by a weak but perceptible dark-gray aura. What you now see is the afterimage of an afterimage. "Optical echoes" of this kind reverberate subtly throughout any combination of contiguous colors.

Finally, concentrate on the black circle and, without shifting your gaze, notice the bright white halo flickering around its edge. (Some students have suggested that the black circle with its white nimbus resembles a solar eclipse.)

4.1

4.2

4.3

Achromatic Afterimages

At the border between two colors we see two simultaneous afterimages. Look closely at the border between the dark and light rectangles in fig. 4.3. On the darker side of the border you will see an even darker band. At the same time, a lighter band will appear on the inside edge of the lighter rectangle. Fig. 4.4 depicts how both afterimages can be seen simultaneously. This phenomenon is known as SIMULTANEOUS CONTRAST.

4.4

Because achromatic grays lack hue and saturation, their mutual afterimages contain only value. When a dark gray casts an afterimage upon a light gray, the afterimage will be lighter in value than the light gray. Conversely, the afterimage cast by a light gray on a darker gray will be darker than its darker neighbor. This holds true even with black and white. The halo surrounding the black circle on a white page is whiter than white, and the blackness on the inner edge of the dot is blacker than black.

4.5

Afterimages in Full Color

The value of an afterimage produced by a color conforms to the same rules that govern those produced by black, white, and achromatic grays. As with noncolors, dark colors project light afterimages upon light colors. The difference with color, however, is that the afterimage also contains hue.

Re-create the "black circle" experiment with the prismatic blue circle seen at right (fig. 4.5). Its afterimage is not only lighter than that within the square, but also has a discernible hue, that of blue's complement: orange.

If the blue circle is placed against a lighter achromatic gray (fig. 4.6), the afterimage that surrounds it will contain its complement (orange) but will also be lighter than the gray it falls upon. Furthermore, the inside edge of the blue circle reveals a thin ring of darker blue. The gray, being achromatic, influences only the value of the blue and not its hue. Fig. 4.7 depicts this illusion.

4.6 **4.7**

Here is another example of simultaneous contrast in full color: Look closely at the blue-violet circle against the green square (fig. 4.8). Immediately inside the blue-violet circle is a thin ring of red-violet. The reddish afterimage of the green is blended optically with the blue of the circle to create this red-violet illusion. Compare the same blue against gray (fig. 4.9). Here, with no green to redden it, the circle appears bluer.

When two colors differ in value and hue, the afterimages they cast on a third color will also differ in value and hue. A violet circle seen against a dark red-orange (fig. 4.10) will appear both lighter and bluer than it will when seen against a light blue-green (fig. 4.11).

The blue circles in figs. 4.12–14 are physically identical but, due to color interaction, appear to differ markedly in each color context.

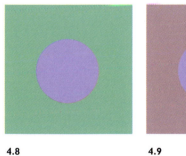

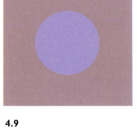

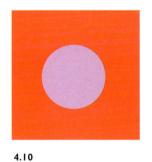

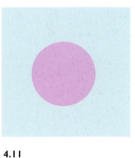

4.8 4.9 4.10 4.11

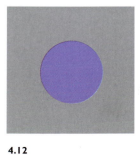

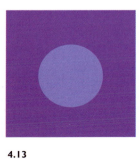

4.12 4.13 4.14

OPTICAL MIXING

When a field of color is composed of small, particulate color shapes, one's mind fuses the disparate visual phenomena into a comprehensible whole. This is called OPTICAL MIXING. The size of the increments and their distance from the eye determine how seamlessly the parts congeal. Four-color printing, digital imaging, and color photography all involve the visual synthesis of thousands of tiny dots or flecks of color. In these cases the dots themselves are barely visible, if at all.

Sometimes, as with mosaics and woven textiles, the small individual units of color are big enough to see, yet still manage to meld into a larger cohesive image. Such visual duality tends to make the viewer unusually conscious of the act of seeing.

This detail of a mosaic from Ravenna (fig. 4.15) demonstrates this dual mode of vision. The color is congealed by the mind, blending individual fragments into larger tonal masses. The face of the youthful Jesus can be read both as a visage or as an aggregate of colored bits. Greater distance (or smaller-sized color fragments) would favor the more illusionistic interpretation, while less distance and larger fragments would yield a cruder illusion.

Pierre Bonnard (1867–1947), the great French painter and colorist, constructed his pictures out of many small touches of color. Unlike the Impressionists, whose method of paint application was similar but who depicted reflected light as they observed it, Bonnard *imagined* the light in his paintings. His images rely on optical mixing for their richness and liveliness. They crackle with an internal, flickering light achieved through shifts of temperature in tones of similar value (fig. 4.16).

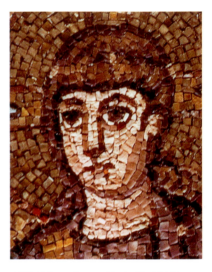

4.15 Maker unknown, *Head of Youthful, Clean-Shaven Jesus*, detail of *The Widow's Mite*, 6th century, mosaic, S. Apollinare Nuovo, Ravenna.

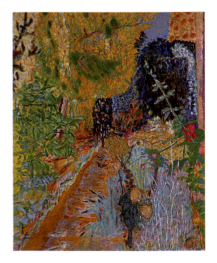

4.16 Pierre Bonnard, *The Garden*, c. 1936, oil on canvas, Musée du Petit Palais, Paris.

Optical mixing can also reinforce a few repeated colors with their afterimages to create a synthesized overall tonality. In fig. 4.17 an achromatic gray square is covered with a grid of smaller, darker squares. If you stare intently at the intersections of the small squares, you will begin to notice even smaller circular shapes, as illustrated in fig. 4.18. The value of those shapes is between that of the light-gray field and the smaller, darker squares.

In fig. 4.19 the same phenomenon is repeated with two colors in place of achromatic grays. Again, the value of the afterimage that appears at the intersection is more or less halfway between that of the field and squares, but this time hue is also a factor. The afterimage at the intersections combines the light blue of the field and the orange of the squares (fig. 4.20).

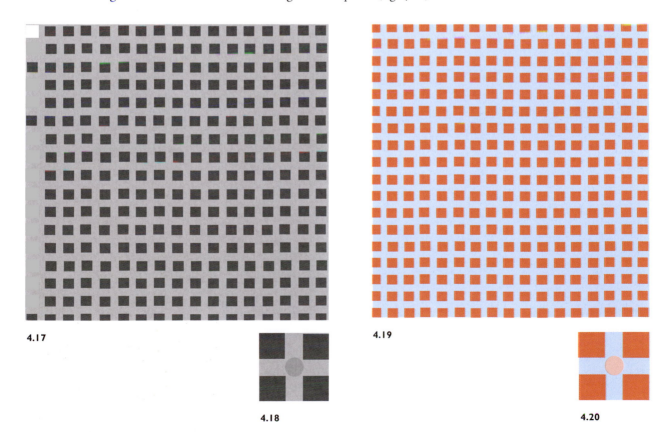

4.17

4.18

4.19

4.20

Interaction and Tonal Progression

When combined with color progression, the effects of simultaneous contrast can be striking. The constant blue-green band in the progression below (fig. 4.21) appears to change as it moves from left to right.

In fig. 4.22 a series of verticle stripes are shown to be a consistent blue. In fig. 4.23 the shifting background color variously transforms the same blue stripes.

4.21

4.22 4.23

JOSEF ALBERS

Josef Albers (1888–1976) was the most influential color educator of the second half of the twentieth century. He began his career at the Bauhaus in Germany, where he was a student and an instructor. Emigrating to the United States in 1933, he made his greatest impact on American art and design through his teaching at Black Mountain College and later at Yale University. In 1963 he published a limited edition of silkscreened color studies titled *Interaction of Color*. This seminal work was Albers's enduring pedagogical achievement.

The original edition is more than a book. It is a rich repository of discoveries made by Albers and his students over the course of several years. Albers's text has considerable charm because it reflects his sense of wonder at the mystery of color relationships.

One of Albers's classic experiments was to make one color appear as two. His favored motif was the square within the square. First, he would show what appeared to be two smaller squares of differing tone against two different background colors (fig. 4.24). Then he would mask out the backgrounds with white, revealing that the small squares were physically identical (fig. 4.25).

Albers was fascinated by the subtle and unpredictable nature of color interaction. He believed that only through careful and sustained experimentation with color relationships could one attain a significant understanding of their intricacies. Albers's teaching method was elegant: a regimen of closely observed color events staged within a controlled setting.

Square-on-square studies are a good way to investigate color interaction. By this time, you have probably amassed a large supply of leftover painted papers. Use them in the next assignment.

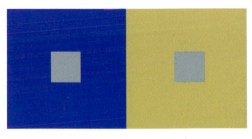

4.24

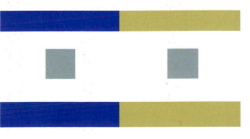

4.25

ASSIGNMENT 5

Interaction Studies

5A. Try to make a single color appear as two different colors by altering its surroundings. This experiment requires close observation and repetition. Devote considerable time to it—perhaps several two-hour sessions. Work to produce ten strong examples.

Begin by altering only the value of an achromatic gray. This is easy because hue and saturation are not present. It is a useful exercise because what you learn about altering value also applies to full color. After doing a few studies in achromatic gray, explore value adjustments in full color at all saturation levels. Organize your studies as shown below. Make the large squares 2 x 2 inches (5 x 5 cm) and the small ones ½ x ½ inch (1.25 x 1.25 cm).

Examples:
Figs. 4.26–27

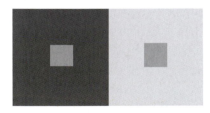

4.26

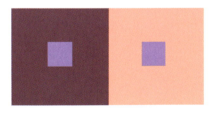

4.27

5B. Now try to achieve a shift in hue but not value. Make a number of these at all levels of saturation.

Example:
Fig. 4.28

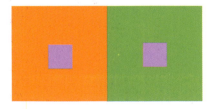

4.28

5C. Finally, try to get a visible difference in hue and value.

Example:
Fig. 4.29

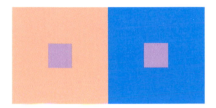

4.29

An interesting variation is to invert the procedure and attempt to make two different colors look as much alike as possible (fig. 4.30).

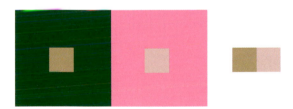

4.30

5D. After making numerous square studies, create a composition in cut-paper collage using the principle of simultaneous contrast. Try to give specific colors at least two different identities throughout your design.

Examples:
Figs. 4.31–32

Rationale: Because of the nature of color vision, a color can appear to change in hue, value, or saturation when seen in various contexts. Sometimes the change is very subtle, sometimes it is so dramatic it strains credulity. These studies are designed to explore the optical effects colors impose upon each other and to make it possible to anticipate them to a degree.

4.31

4.32

Shown below is an example of an interaction composition of six colors with
a numerical key to indicate color repetitions (fig. 4.33).

4.33

In the textile arts, designers are frequently limited to a few specific tones. Severe color limitations can be embraced as part of the design process. The intelligent use of a few colors can lend clarity and unity to a color composition, as shown in this Indonesian batik (fig. 4.34).

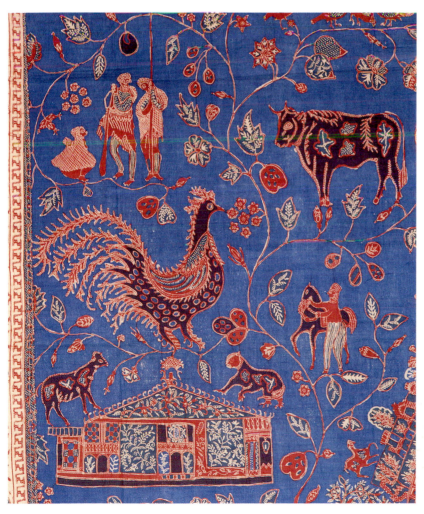

4.34 Maker unknown, Detail of sarong from Indonesia, c. 1898, batik, British Museum, London.

This contemporary quilt (fig. 4.35) uses the same few colors repeatedly in shifting contexts. The result is a surprising sense of variety and richness. The same can be seen in the textile design and tapestry shown on the next page (figs. 4.36–37).

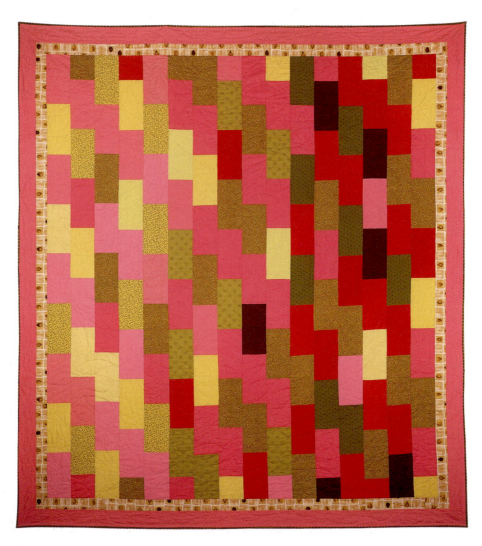

4.35 Lydia Neuman, *Cobblestones: Pink and Green*, 2002, knotted linen, Collection of Michie McConnell, Berkeley, California.

4.36 Silver Studio for G.P. & J. Baker, *Hemlock*, 1805, design for fabric,
Victoria and Albert Museum, London.

4.37 Nicolas Bataille, *The Second Trumpet: The Shipwreck, Apocalypse of Angers No. 21*,
1373–87, tapestry, Musée des Tapisseries, Angers.

FREE STUDIES

Carry ideas from the color interaction assignments into your free studies, as
in figs. 4.38–39, or conduct color experiments of your own in a comfortable
format (figs. 4.40–43).

4.38

4.39

4.40

4.41

4.42

4.43

5. APPLICATIONS

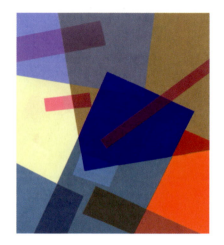

"It is well to remember that a picture, before being a battle horse, a nude woman, or some anecdote, is essentially a plane surface covered with colors assembled in a certain order."

Maurice Denis

The lessons of Parts One to Four have prepared us for more challenging studies involving tonal progression, the illusion of transparency, and observational painting. These new assignments will demand more precise mixing skills than the earlier studies. They are designed to deepen understanding while introducing color strategies that are useful in two-dimensional art and design.

TONAL PROGRESSION

To artists and designers, the grayscale is the most familiar example of progression. Grayscales usually consist of ten or eleven shades starting with black and ending at white. Painting an achromatic grayscale is a common feature of introductory design curricula. But although it is a useful exercise, it is strictly limited to value. Progressions that shift in hue and saturation as well as value are far more challenging to make and have a deep inherent light.

Another limited aspect of the traditional grayscale is its range, which runs the gamut from black to white. Tonal progressions need not encompass a full range of hue, value, or saturation. In fact, covering a limited distance within a larger range of tones makes for more subtle, evocative progressions, as shown at right (figs. 5.1–3).

Three tonal progressions with limits:

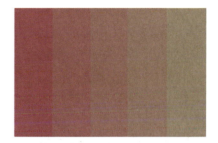

5.1 A limited progression with emphasis on shifting hue and subtle value transition.

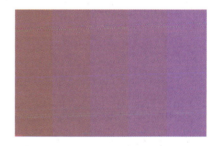

5.2 A limited progression with emphasis on saturation (chromatic gray to muted color).

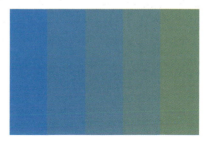

5.3 A limited progression emphasizing hue (blue to yellow-green).

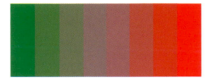

5.4 Progression in hue and saturation.

5.5 Progression in hue and value.

5.6 Progression in hue, value, and saturation.

Tonal progressions can occur *simultaneously* in two or three structural categories, with different rates of change within each color part as shown in the examples above (figs. 5.4–6). The progression on the right (fig. 5.7) has a broad shift in hue (it includes all primaries and secondaries in seven steps), a moderate shift in saturation (muted color to chromatic gray), and a narrow value range (upper mid-tone to lower mid-tone).

Two progressions can be interposed so that each seems to move in opposite directions. Seen below are two different tonal sequences. Fig. 5.8 graduates from prismatic red at the top down to a chromatic gray version in the middle, and back to the same prismatic red at the bottom. The range of saturation is great, but hues and values shift only slightly.

Fig. 5.9 starts at the top with a pure, prismatic yellow and descends to prismatic violet. The intervening tones are cross-mixtures of the two complementaries. Here, the hue and value range is much broader than in fig. 5.8. The saturation range is also broad because it contains prismatic color, muted color, and chromatic gray. As in fig. 5.8, the colors at the top and bottom are the most saturated while those in the center are the dullest.

5.7 This progression has different rates of transition in hue, value, and saturation.

5.8

5.9

In fig. 5.10 the two previous progressions (figs. 5.8–9) are visually interspliced, producing unexpected results. The value sequences of the two parts seem to run counter to each other, with the least contrast of value concentrated in the center. Although the reds at each end are physically identical, they appear to be two different colors.

Combining contrary sequences in more complex design configurations can produce rich results. Subtle tonal progressions, in particular, can impart a mysterious quality even to hard-edged geometric designs (figs. 5.11–13).

5.10

5.11

5.12

5.13

Informal Tonal Progression

Tonal progressions can be applied somewhat loosely and still evoke sequence and luminosity. Figs. 5.14–16 exemplify informal or intermittent progressions.

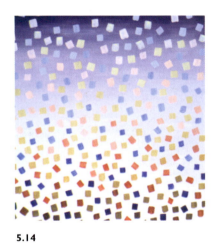

5.14

5.15

5.16

Color progression can also be joined with sequences in shape and interval (figs. 5.17–18).

5.17

5.18

This mosaic and painting (figs. 5.19–20) both use color progressions in a palette of chromatic grays, but with differing intent. In the mosaic, progressions are arranged to describe solid form, while Itter's painting deploys color shifts to evoke movement and spatial ambiguity.

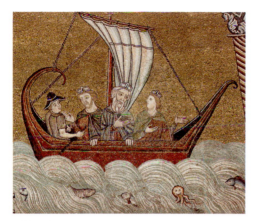

5.19 Maker unknown, *Journey of the Magi*, mosaic, Bapistry, Florence.

5.20 William Itter, *Axis I: Home At Four Corners*, 1997, oil on cotton, Indiana University Art Museum, Bloomington, Indiana.

Instead of blending colors to create the illusion of forms, Paul Cézanne used tonal progressions (fig. 5.21; detail shown at right). His graded brushstrokes indicate form while at the same time implying an encompassing state of flux.

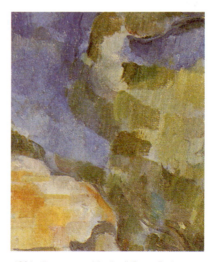

5.21 Paul Cézanne, *Rocks Near the Caves Above the Château Noir*, c. 1904, oil on canvas, Musée d' Orsay, Paris. (Detail shown at right.)

5.22

5.23

ASSIGNMENT 6

Progression Studies

6A. Paint two separate sets of colored strips on vertical rectangles each approximately 4 inches (10 cm) wide. They do not need to be identical. In the examples at right, one set of strips (fig. 5.22) is thinner than the other and the second (fig. 5.23) has uneven increments. Bisect each rectangle from top to bottom and cut the strips of color apart. Arrange them into three configurations. First, show each progression separately (as in figs. 5.22–23). Then, integrate the two sequences. Each progression should involve at least two parts of color (e.g., hue and value, or value and saturation, etc.).

Examples:
Figs. 5.22–24

5.24

6B. Create a design that incorporates progression in hue, value, and saturation. For added interest, you might extend the concept of progression to other formal variables such as shape or interval.

Examples:
Figs. 5.25–27

Rationale: Painting color transitions will reinforce your understanding of fundamental color concepts while enhancing your mixing skills. When understood in terms of hue, value, and saturation, color progressions amplify the effect of inherent light in color.

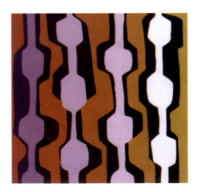

5.25

5.26

5.27

This modern quilt employs the illusion of transparency to make two squares appear to slowly emerge from the center.

TRANSPARENCY

By suggesting the passage of one plane in front of another, the illusion of transparency can enhance the appearance of spatial depth in two-dimensional design. (Illusionistic transparency, made with opaque color, should not be confused with the *literal* transparencies of watercolor washes or glazes in oil painting.)

Transparency studies are difficult to execute because they require precise mixing and painting skills. The illusion makes one shape appear to overlap another so that a third shape, which seems to be part of each, is created between them.

Imagine two translucent rectangles superimposed at right angles to form a cross (fig. 5.29). Emerging at the intersection of the cross is a square. The color of this central square determines the persuasiveness of the illusion.

There are two distinct categories of transparency useful in design applications. With the first, MEDIAN TRANSPARENCY, the hue and value of the overlapping area (the center of the cross) lie precisely halfway between the hue and value of the two parent colors (the wings of the cross). For example, if yellow traverses blue (fig. 5.29), the square in the center will be of middle value because yellow is relatively light and blue relatively dark. It will also be green because green sits between yellow and blue on the color wheel. Both the hue and value of the center square are in between that of the two parent colors.

The second type of transparency, DARK TRANSPARENCY, is so called because the intersecting tone is darker in value than both overlapping colors. When a dull orange and a blue-green of similar value cross, for example, the intersection is a square that is darker than both the orange and the blue-green (fig. 5.30). As with median transparency, the hue of the intersection is a fusion of the two parent colors.

5.28 Ellen Oppenheimer, *Log Cabin Maze*, 1992, hand-painted and quilted, sewn, and dyed fabric, Smithsonian American Art Museum, Washington, D.C.

5.29 In a median transparency, the value and hue at the overlap are in between those of the parent colors.

5.30 In a dark transparency, the color at the overlap is darker in value than the two parent colors, but precisely between them in hue.

While both forms of transparency can produce convincing illusions, each has inherent limitations. Median transparencies work well when the parent colors differ in value. When one parent is clearly lighter than the other, it is easy to place a readable median tone at the overlap.

But when the parents are close in value, as in fig. 5.31, a median value would not be distinguishable at the intersection. If median transparencies were the only available option, the designer would be unable to apply transparency to any overlapping colors that are alike (or nearly alike) in value. The solution for the problem presented in fig. 5.31 is fig. 5.32, a dark transparency.

Dark transparencies are more flexible and more forgiving than median transparencies. But variety lends interest, and each has its charm. In situations where either might work, the choice is an aesthetic one.

There is one condition under which neither medium nor dark transparencies can produce a legible illusion, i.e., whenever the two parent tones are dark and equal in value (fig. 5.33). In such cases, their values are too similar to permit a median transparency and too dark for a darker tone to be clearly readable.

Transparency studies challenge the colorist to mix accurate tones in median transparencies and to judge precisely how dark the central color needs to be in dark transparencies. The target color is narrow in each case and requires a discerning eye. (Bear in mind that these are conceptualized transparencies based on the assumption that the overlapping material is pure color and not fabric or glass, where one could suppose one material to be thicker or relatively more opaque than the other. Imagine each parent color to be of equal density.)

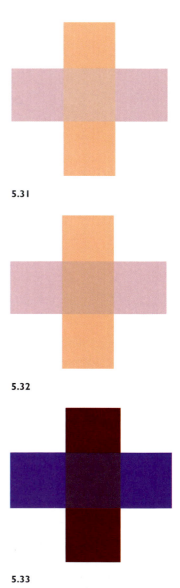

5.31

5.32

5.33

ASSIGNMENT 7

Transparency Studies

7A. Create a series of crosses demonstrating both median and dark transparencies (about six of each). Try to use diverse hues, values, and levels of saturation. (These can be painted directly if carefully masked or they can be made by gluing painted paper.)

Examples:
Figs. 5.34–35

7B. Compose a design that contains several incidents of each kind of transparency. While you may approach composition freely, strive for readability in color choice and shape description.

Examples:
Figs. 5.36–37

Rationale: The illusion of transparency can be a useful tool, especially for graphic and textile designers. But the primary goal of this assignment is to further refine skills in color mixing, seeing, and understanding. These are difficult studies to execute because both understanding and craft must be precise. Colors at intersections should be carefully mixed for appropriate hue, value, and saturation. Edges must be clearly painted or inlaid to make the illusion legible.

5.34 Median transparency.

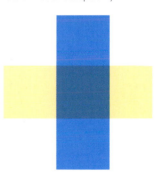

5.35 Dark transparency.

5.36

5.37

RETINAL STUDIES

French Impressionism revitalized the role of color in Western art. Inspired by encounters with Eastern art and contemporary color theory, the Impressionists developed a way of painting that, at its most extreme, sought to replace drawing as the basis of pictorial composition with the objective transcription of color shapes as observed in reality. Claude Monet (1840–1926), in particular, attempted to build his pictures strictly out of his response to visual sensations. He proposed that the painter should record only the patterns and colors that fall on the retina and ignore the "identity" of the subject (see figs. 1.1–2 on page 12). This constituted a new kind of realism that reflected the physical nature of vision.

In her book *The Artist's Eye* Harriet Schorr has given the name RETINAL PAINTING to this approach. In retinal painting, one concentrates upon color and shape while resisting the urge to name individual objects. When vision is directed in this manner, one actually experiences a different way of seeing. The result is a picture in which the subjects seem to be constructed purely out of color shapes.

Knowing Obscures Seeing

Vision is influenced by our preconceptions about reality. In viewing a scene, we establish unconscious hierarchies that reflect our functional relationship to objects and our momentary priorities. For example, when envisioning a hammer in our mind's eye, we tend to "see" it in profile or at some other "ready for use" angle (fig. 5.38). One would probably not visualize a hammer as seen from the top so that the handle is hidden by the hammer's head (fig. 5.39). The functional relationship we have with objects creates visual expectations that interfere with our ability to see "like a camera."

The camera, like the human eye, sees only shapes and colors. It documents the world impartially through a lens that is similar to the eye. When we look at them carefully, photographs are often surprising because they don't interpret confusing details but simply serve them up to us with a mechanical indifference. And because of their flatness, photographs often contain areas that appear as unrecognizable colors and shapes.

5.38

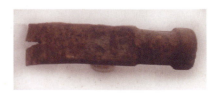

5.39

Retinal Painting

Despite its directness, retinal painting from observation is more difficult than one might think. One must surrender to sensation, which at first may feel out of control. Most people find it hard to overcome visual habit; they tend to ignore what they see in favor of what they "know." As an introduction to retinal painting it can be helpful to make a few practice studies from photographs (figs. 5.40–42).

In working from photos, take care to paint only with patches of color corresponding to those you see in the image, regardless of the subject. Notice that there are no contour lines in a photograph. Painting in this way is somewhat easier than working directly from life because the photo translates three-dimensional forms into flat colors and shapes.

5.40

5.41

5.42

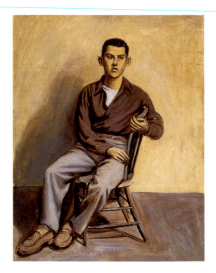

The best-known American practitioner of retinal painting in the later part of the twentieth century was Fairfield Porter (1907–75). But early in his career Porter's paintings were somewhat linear, rooted in drawing. This portrait from 1938 (fig. 5.43) is a good example of his early style. Here, color is secondary to drawing, and consciously organized to describe what he knew about the figure in space.

A later portrait (fig. 5.44), made in 1965, shows a more retinal painting procedure. A comparison of details from both paintings reveals essential differences between the two approaches. The earlier head (fig. 5.45) demonstrates Porter's preoccupation with an almost sculptural rendering of form. It is nearly monochromatic, with an emphasis on value. Porter was interpreting the head as a volume in space.

The later head (fig. 5.46) is less sculptural and seems to be bathed in atmospheric light. Here Porter is interested in getting the precise relationship of the color tonalities he is seeing. Subtle temperature shifts flicker within the chromatic grays that make up the shadows. Here, moreover, shadow is treated as trapped light, unlike his earlier conception of shadow as a dark value from which forms are visually "modeled."

As Porter's style matured, he subordinated the illusion of solid form to his pursuit of color. Subjects are frequently lighted so softly that shadows and highlights are close in value.

5.43 Fairfield Porter, *Seated Boy*, 1938, oil on masonite, Parrish Art Museum, Southampton, N.Y., Gift of the Estate of Fairfield Porter, 1980.10.4.

5.44 Fairfield Porter, *Anne*, 1965, oil on canvas, The Parrish Art Museum, Southampton, N.Y.

5.45 Detail of fig. 5.43.

5.46 Detail of fig. 5.44.

An important rule of thumb in retinal painting is to paint *only* what you see, but not *everything* you see. The goal is to probe the subject for colors and shapes and to transcribe them as accurately as possible. Rough in the largest shapes until you have covered the whole picture plane. Then decide on a secondary level of visual detail and paint those smaller shapes within the larger ones. Finally, work down to the smallest shapes you care to record. A rendering of even a few major color shapes, if faithful to observation, will have the authority of simple truth.

ASSIGNMENT 8

Retinal Studies

8A. Paint a series of four to six retinal landscape studies in gouache. Each painting should be approximately 7 x 9 inches (17.8 x 22.9 cm). To make the initial paintings come more easily, use adhesive tape to mask out a rectilinear viewfinder on a window pane. (The painting's format should have the same proportions as the taped rectangle.) The viewfinder will frame the scene and reveal shapes in the visual field not only in relationship to each other, but also in relation to the boundary of the rectangle. Paint the large, major shapes first, covering the entire picture plane before beginning to add any subsidiary tones. Try to render colors precisely as you see them. If colors are mixed with care, the resulting picture can evoke the time of day or prevailing weather conditions.

Examples:
Figs. 5.47–50

These images of downtown Providence were done by the same student at different times of day.

5.47

5.48

5.49

5.50

8B. Paint a series of still-life paintings in gouache at approximately 7 x 9 inches (17.8 x 22.9 cm). Some should be from arranged objects (as in figs. 5.51–53) and others should simply be happened upon (figs. 5.54–56). A small rectangular cardboard viewfinder that exactly matches the shape of the format can help you isolate your composition.

Examples:
Figs. 5.51–56

Rationale: Retinal studies are not only beneficial to painters and illustrators. Although painted images, not designs, are the outcome, the process is instructive to all visual artists because it requires the accurate transcription of colors and shapes from three dimensions to two.

These studies require little drawing skill. You can restrict yourself to recording only the dominant shapes in a scene or engage the subject in intricate detail (working from large shapes to small). In either case you will learn to prioritize visual material and render colors under ambient light.

5.51

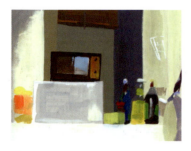

5.52

5.53

5.54

5.55

5.56

The historical transition from indirect procedures predicated on drawing (and codified by the French Academy) toward direct color painting (Impressionism) precipitated a sea change in the way many artists perceived the art of painting. By the end of the nineteenth century a new emphasis on color had emerged, along with a heightened awareness of the effect of process upon content and a recognition of the importance of the materiality of paint. Each of these developments foreshadowed early modernism and set the stage for twentieth-century abstraction.

The paintings of Richard Diebenkorn (1922–93) clearly demonstrate the fundamental link between retinal painting and abstraction. Throughout his painting career Diebenkorn vacillated between representational and abstract painting styles. His pictorial paintings are essentially retinal in approach (fig. 5.57).

Despite lacking direct pictorial references, Diebenkorn's abstract paintings are very similar to his representational images. When working abstractly, he substituted geometric shapes for objects like sinks, tables, windows, and chairs (fig. 5.59). In either format, he focused upon the character of marks, color nuance, shape-making, and proportional refinement.

5.57 Richard Diebenkorn, *Corner of Studio Sink*, 1963, oil on canvas, Private Collection.

5.58 Detail of fig. 5.57.

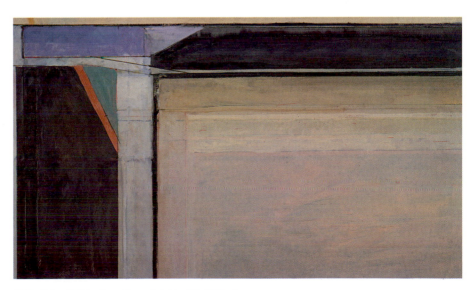

5.59 Richard Diebenkorn, *Ocean Park No. 120*, 1980, oil on canvas.

FREE STUDIES

These studies (figs. 5.60–64) demonstrate a range of color interests and approaches to process and materials.

5.60

5.61

5.62

5.63

5.64

The studies on this page all employ indirect methods of mark making. In fig. 5.65 corrugated cardboard is used as a printing tool; in fig. 5.66 onions are painted and stamped into a design; string and a roller are used in fig. 5.67; and in fig. 5.68 bubblewrap packing material is transformed into a printing tool.

5.65

5.66

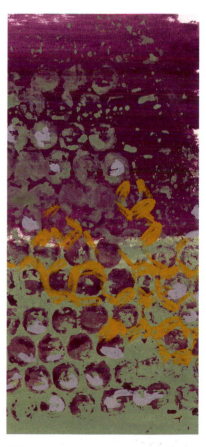

5.68

5.67

6. COLOR UNITY

"The word 'art' means harmony for me. I never speak of mathematics and never bother with the Spirit. My only science is the choice of impressions that the light in the universe furnishes to my consciousness as an artisan, which I try, by imposing an Order, and Art, an appropriate representative life, to organize…"

Robert Delaunay

COLOR RELATIONSHIPS

When considering color relationships, try to transcend ideas you may have about fashion and good taste. It is more useful to focus upon the quantifiable characteristics of color groups. Rather than "what colors go together?" ask "how do colors go together?" Think about unity, disunity, and the steps in between.

When colors share visual qualities, we perceive them as interdependent or unified. The less they have in common, the more colors assert their independence in a group. Disunity, or the assertion of independence, can evoke a sense of visual tension.

Every hue in the color spectrum has its complement (or polar opposite) on the color wheel (fig. 6.1). The complements of all three primary hues are secondary hues that contain the remaining two primaries. For example, the complement of red is green, which contains the remaining two primaries, yellow and blue.

The polarity of complements makes them stand in contradiction to each other. As discussed in Part Four, when two prismatic complements are juxtaposed, their afterimages amplify their mutual distinction. In fig. 6.2 the red appears redder and the green greener by virtue of their being joined.

When values are similar and saturation is low, diverse hues can appear more unified. In fig. 6.3 the complements red and green are both chromatic grays at mid-value. While they remain distinct as hues, aligning their value and softening the effect of afterimage through lowered saturation makes the contrast seen in fig. 6.2 appear considerably mitigated.

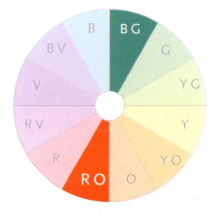

6.1 A hue wheel emphasizing the complementary pair blue-green and red-orange.

6.2

6.3

UNIFYING STRATEGIES FOR COLOR MIXING

1: A Palette of Primary Colors

An almost foolproof way to achieve family resemblance among a group of colors is to generate them from a limited source. Intermixing any primary triad (plus white) can produce a wide range of tones that share a common light quality.

Any particular red, yellow, and blue will give you access to all hues. But, as described in Part Two, color overtones associated with specific pigments will limit possible saturation range. These limitations can be thought of as an expression of the character of illumination inherent in a color. Just as a fluorescent light bulb produces a characteristic quality of light that unifies what it illuminates, any primary triad exerts a characteristic quality of inherent light through intermixing.

ASSIGNMENT 9

Triadic Dot Study

9A. Choose a primary palette consisting of a particular triad of red, yellow, blue, and white. Bear in mind that your choice of primaries will determine which colors will be capable of the highest saturation. For example, a triad of scarlet, golden yellow, and ultramarine blue will yield a vivid orange but not highly saturated greens. On the other hand, a triad of earth tones (burnt sienna, ocher, and blue-gray, for example) could never produce a prismatic version of any hue. Its entire tonal range would be limited to chromatic grays and weak muted colors. Any primary triad will have inherent limitations, but these are what give a palette its character.

Because of its complexity, a triadic dot study should be painted systematically. To explore the inherent light in any primary triad, try following this sequence (figs. 6.4–8):

1. Paint the background in a mid-tone made by mixing all three colors plus white (fig. 6.4).

6.4

6.5

6.6

6.7

2. Place the original primaries within the study (fig. 6.5).

3. Paint one dot for each color of the primary and secondary triads in mid-tones (fig. 6.6). (In order to arrive at mid-tones you will need to adjust the value and saturation levels of each color.)

4. Mix dark versions of each hue and place them directly beneath the mid-tones (fig. 6.7).

5. Mix light tints of each hue and place them at the bottom (fig. 6.8).

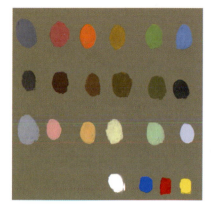

6.8

9B. Create a composition based on your color triadic dot study.

Example:
Fig. 6.9

Rationale: The first part of the assignment, a triadic dot study, teaches a mode of examination that, in a few steps, summarizes the tonal range of a selected palette. The follow-up (9B) applies the colors of the study to a composition and puts the palette into action. Comparisons between the compositional study and the finished inventory clarify just how the inherent light in a design or painting is a projection of the palette from which it originates.

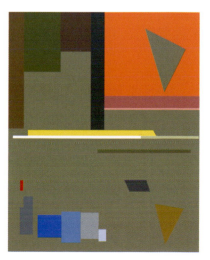

6.9

9C. Paint or collage two compositions using only tones derived from two distinct primary triads.

Examples:
Figs. 6.10–11

The compositions may be identical (fig. 6.10) or simply related to each other (fig. 6.11). If identical, try to match the colors as closely as possible. (Examples are shown with their original palettes.)

Rationale: To create "twin" or even similar images from two distinctly different primary triads clarifies the quality of light implicit in each triad. In the case of the matching image, there is an additional benefit. Matching colors in the second image to those in the first is, in every instance, a lesson in the significance of the initial palette. Struggling for the closest match possible, you will find yourself negotiating hue against value, or saturation against hue. When an exact duplication of a color is impossible, which of its characteristics is most imitable?

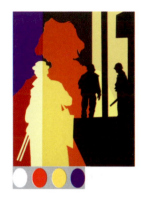

6.10

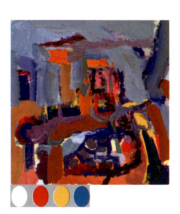

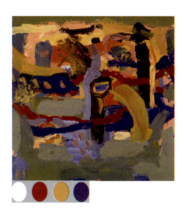

6.11 In this, the looser interpretation of assignment 9C, the studies differ from each other in some of their specifics, but are still close enough in character to reveal the quality of light inherent in each of the two palettes.

2: The Altered Palette

Another way to achieve color cohesiveness is by adding a small amount of a single color into every color on the palette before beginning. Fig. 6.12 shows four colors of an original palette on the left and the same four colors again on the right after they have been altered by the color in the center, raw umber. Because of their common admixture, the color grouping on the right is more unified than that of the original colors.

The effect of an altered palette resembles that of a piece of colored film placed over a group of colors. It can also suggest an enveloping light akin to theatrical stage lighting.

ASSIGNMENT 10

Exploring an Altered Palette

10A. To see the effect of admixture clearly, paint a study in flat colors from a palette of three to five colors (plus white) chosen at random. Use the color directly from the palette without mixing any new tones.

10B. Now mix a small but perceptible amount of an admixture into each of the colors on the palette and re-create the design. Earth tones are usually chosen for the admixture, but any color can work. (Note: Because pigment strength varies from color to color, some colors may be altered more noticeably than others. Practice will enable you to find the proportions necessary to unify the palette without sacrificing the essential character of the original colors.)

Examples:
Figs. 6.13–15 (shown overleaf)

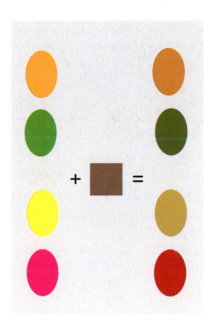

6.12

Rationale: Altering a palette of diverse colors requires a surprising amount of sensitivity to the specific nature of each pigment. As one becomes engaged in the procedure, interesting questions arise. For example, should white be altered? If it is, what are the implications for the possible value range of the palette? Also, what is the relationship between the admixture and each original color? Suggestion: In free studies, you might try using an altered palette with original colors as visual accents.

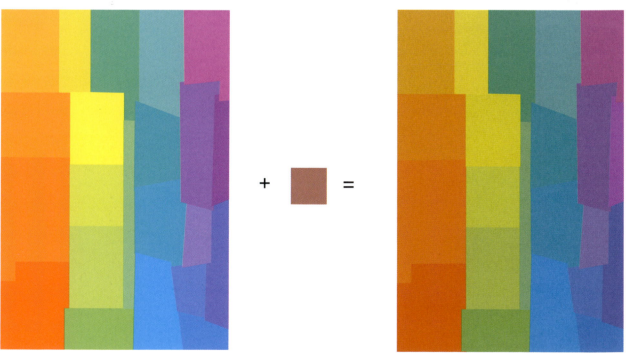

6.13

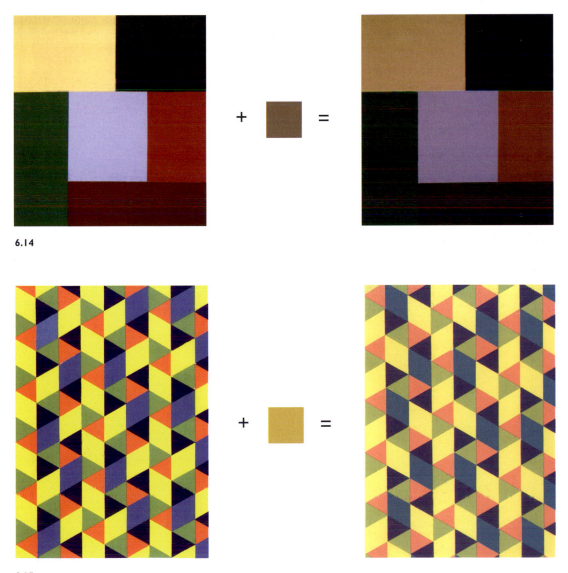

6.14

6.15

3: The Two-Color Palette

As with the primary triad, two carefully selected colors can produce a wide range of tones that will bear a family resemblance to each other. In a two-color palette, the choice of the original colors should be made with a view to possibilities. For example, a mixture of two earth tones would result in chromatic grays, precluding the possibility of muted or prismatic colors. Any pair of prismatic complements, on the other hand, can generate a broad value and saturation range.

ASSIGNMENT 11

Dot Study: A Two-Color Palette

11A. This study begins with a palette of any two complementary colors plus white (fig. 6.16). The complementary pair can be of any saturation level; in this example it is an earth-tone yellow and a muted violet. Intermix these colors to create a flat tone for the background (fig. 6.17). Make the format approximately 6 x 6 inches (15.2 x 15.2 cm). (Although the background tone shown in fig. 6.17 is dark, it might be of any value.)

When the background is dry, mix the two colors of the palette in a variety of proportions to generate approximately fifteen different tones. Paint one dot of each tone on the background (fig. 6.18). Each dot should be painted freehand and be no larger than a dime. Do not repeat a tone. Note: It is important to create a broad value and saturation range. The number of dots is a matter of choice and can vary from study to study.

6.16

6.17

6.18

6.19

Example:
This study (figs. 6.19–21) uses the "near complements" green and orange as original colors.

6.20

IIB. Create a composition using a selection of tones from your dot studies.

Examples:
Figs. 6.22–23

6.22

6.23

6.21

Rationale: A two-color palette can yield a surprisingly rich array of colors. While making your selection of the original colors, try to anticipate tonal possibilities in hue, value, and saturation. This assignment fosters an appreciation of the expressive potential inherent within self-imposed limitations.

Colors with a Lot in Common

The colors in the two grids shown right are all in the same hue family (red-violet) and are all chromatic grays. Both grids are therefore highly unified. The differences between them are small and center around their value relationships. In fig. 6.24 the values are very closely aligned, while in fig. 6.25 they are diverse. This difference makes fig. 6.24 slightly more unified than fig. 6.25.

The grids in figs. 6.26 and 6.27 are also very similar. They both have a limited hue and value range. In fig. 6.26, however, the saturation level is also constrained (all muted colors), whereas in fig. 6.27 the saturation range is more diverse, with the inclusion of chromatic grays and prismatic colors. Therefore, fig. 6.27 is somewhat less unified than fig. 6.26.

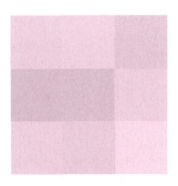

6.24

6.25

6.26

6.27

Disparate Colors

When hue, value, and saturation are all disparate, visual disunity is obvious (fig. 6.28). But even the most incoherent groupings can be softened by the introduction of BRIDGE TONES, intermediate tones that share qualities with each of two (or more) disparate colors.

For example, in fig. 6.29 two colors that are very different in hue and saturation (a bright scarlet and a gray-green) are placed side by side. In fig. 6.30 a three-step progression in hue, value, and saturation appears between the original colors to make a "bridge" connecting them.

6.28

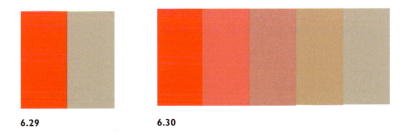

6.29 **6.30**

The way colors are arranged can also influence the cohesiveness of a color group. A sixteen-color grid based upon the last example (figs. 6.29–30) is shown at right (fig. 6.31). The tones are organized in a way that heightens their differences. No two reds have common borders, and their value relationships are random.

A second version (fig. 6.32) shows a more unified distribution of the same tones. This arrangement places the transitional tones where they have the most unifying effect.

6.31

6.32

COLOR ANOMALY

How much unity is desirable? It depends on the function or meaning of a design. For example, wallpaper designs tend to be highly unified because their function is (usually) to quietly enliven a room without overpowering the viewer.

In painting, and other expressive forms of visual art, strident disunity among color relationships might be appropriate to gritty subject matter or used as an ironic foil to soft content. Unity, disunity, and all the stops in between are available options to be considered with regard to the overall intent of the project at hand.

ANOMALY refers to any element that runs against the grain of a consistent whole, such as a circle on a grid of squares. A *color* anomaly is a single color that contradicts, through difference, the overall character of the color field in which it appears.

Color anomalies may be of hue, value, saturation, or combinations thereof. For example, against a group of chromatic gray tones derived from a narrow range of hues and values, a single muted color will appear anomalous because of its higher saturation, despite the fact that it shares value and hue with its surroundings (fig. 6.33).

If the anomaly is not only one of saturation but also of value, the result is more emphatic (fig. 6.34).

And if the anomaly is one of hue, value, *and* saturation, as in the third variation (fig. 6.35), the sense of visual disjunction is extreme.

Extreme anomaly provokes momentary visual shock, but more subtle disturbances can add interest to a color field by exerting a quiet tension on the cohesiveness of the whole. The next assignment focuses on controlling the visual tension in a color field.

6.33

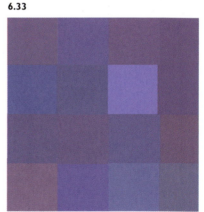

6.34

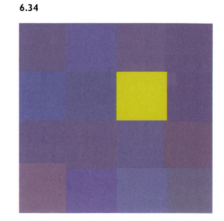

6.35

ASSIGNMENT 12

Anomaly and Bridge Tones

12A. Create a tightly unified color field such as the one shown at right (fig. 6.36) and make two exact copies of it so that you have the original in triplicate. This example is based on a complementary scheme with transitional tones. Values are concentrated in the darker half of the value gamut. Monochromatic or analogous schemes also make a good starting point for this assignment: see the glossary for definitions.

12B. To one of the versions add a single color that is an anomaly in hue, value, or saturation, or a combination of all three (fig. 6.37).

12C. Change two of the existing colors to create bridge tones that will soften the starkness of the anomaly (fig. 6.38). (In this example the new colors reflect the blueness of the anomaly and its relative lightness in value.)

Examples:
Figs. 6.36–38

Rationale: This exercise requires a subtle understanding of the structure of color and the importance of color placement. The goal is to soften, not eliminate, the tension caused by anomaly.

6.36

6.37

6.38

FREE STUDIES

Shown below are two pairs of studies (figs. 6.39–40). Each pair uses the secondary triad to explore the effect of color proportion on design. The techniques differ: torn-paper collage and carefully masked horizontal stripes. In the former, the design has a sense of spontaneity and freshness. Orange functions on the left as a positive shape and on the right as a background. The stripe format provides a more formal and systematic way to examine relative proportion.

6.39

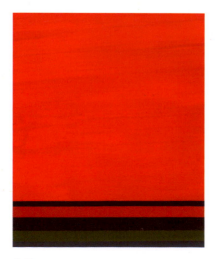 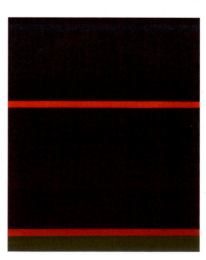

6.40

These free studies, while diverse in many ways, share an overall lightness in value, or luminosity. The lightest (fig. 6.41) is extremely subtle. A visual quietude prevails and a yellow shape in the middle left of the study has an impact that belies its delicacy.

The second example (fig. 6.42) combines soft edges with a light, grayed palette.

Fig. 6.43 has an almost naturalistic aspect, like the patterns found in rocks or shells. The color has been applied extremely wet and allowed to puddle and dry on the paper's rippled surface.

Of the four, fig. 6.44 displays the highest overall saturation. The rich yellow-greens are light in value. Within its narrow hue and value range, the artist makes many subtle shifts of temperature. This study has both luminosity and a deep, inherent light.

6.41

6.42

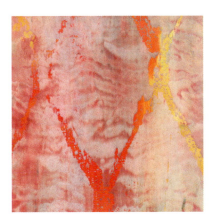

6.43

6.44

7. COLOR RESEARCH

"Color exists in itself, possesses its own beauty. It was Japanese prints that we bought for a few sous on the rue de Seine that revealed this to us."

Henri Matisse

SOURCES

Under the influence of routine, we tend to fall into certain color habits. Our choices can grow stale and predictable if they are not nourished by contact with outside sources. Artists have often looked beyond the bounds of their own work for visual stimulation. For example, Henri Matisse made a lifelong study of color in the decorative arts of Eastern cultures. Vincent van Gogh spent evenings by the fire arranging bits of colored yarn on a gray piece of cardboard. Paul Klee collected and absorbed the paintings of children.

The contemporary British painter Howard Hodgkin is a collector of Indian miniatures whose personal color aesthetic has been enriched by his careful study of these exquisite small paintings. Shown below are a miniature of the kind he has studied deeply (fig. 7.1) and one of Hodgkin's own paintings (fig. 7.2).

7.1 Basohli (India), *The Lonely Krishna Explains His Plight*, c. 1660–70, gouache, Victoria and Albert Museum, London.

7.2 Howard Hodgkin, *The Green Château*, 1976–80, oil on wood.

COLOR INVENTORIES

A good way to assess the color in an image or object you admire is to make an inventory of it. We use two methods of color inventory: proportional and nonproportional.

7.3

The Proportional Color Inventory

A PROPORTIONAL COLOR INVENTORY records the tones found in a source and their relative proportions. This approach is best suited to flat objects that have a countable number of colors. Woodcuts, wallpaper designs, package designs, and modern paintings in graphic styles, e.g., Picasso's synthetic Cubist paintings or Miró's Surrealist abstractions, all lend themselves to proportional color analysis. Textiles can also be inventoried in this way if one deals strictly with the graphic content of the weaving and ignores the structural complexity of the three-dimensional woven surface.

The most efficient way to organize a proportional inventory is in stripes. Color can be applied directly or glued in place as a collage. A printed German banknote from the early twentieth century is shown at upper right (fig. 7.3). Including the paper it is printed on, it has seven colors. Under it is a color inventory showing the seven colors in their estimated relative proportions (fig. 7.4). The goal in making a proportional color inventory is to match the colors and their proportions as accurately as possible.

7.4

ASSIGNMENT 13

A Proportional Inventory

13A. Make a proportional inventory of an object that has an easily countable number of tones. (As previously mentioned, graphic images such as printed textiles, woodcuts, or silkscreen prints make good sources for this type of color assessment.)

13B. Create a composition of your own using the colors and proportions of the inventory.

Examples:
Figs. 7.5–7

Rationale: When we take a palette from an outside source we break away from visual habits and encounter color combinations we might not otherwise consider. The exercise of matching color and estimating proportions trains the eye to assess color objectively.

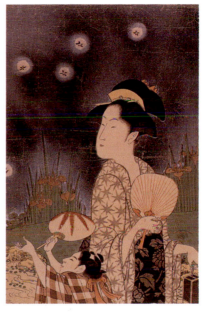

7.5 Eishosai Choki, *Hunting Fireflies,* 1785–1805, woodcut, Musée des Arts Asiatiques-Guimet, Paris.

7.6 Proportional inventory of fig. 7.5.

7.7 Composition derived from proportional inventory.

The Nonproportional Color Inventory

A stone, a pool of water, and a painting by Vermeer all contain an uncountable number of tones. For such objects a proportional inventory is impractical if not impossible—there are simply too many colors. Instead, a NONPROPORTIONAL COLOR INVENTORY of their color content can be made. In a nonproportional inventory, the goal is to summarize the colors found within the object. Here, as in the triadic dot study (assignment 9) the colored dot makes an appropriate visual unit.

The colors in the stone (fig. 7.8) are represented in a dot study (fig. 7.9). The background in this study is a mid-tone taken from the stone. No two tones are alike. An attempt has been made to represent the full hue, value, and saturation range found in the stone. While its numerous colors elude a complete accounting, the dot study provides a faithful and characteristic representation.

7.8

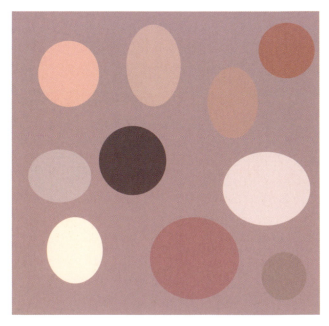

7.9

ASSIGNMENT 14

A Nonproportional Inventory

14A. Begin the inventory with a square of flat color (about 6 x 6 inches [15.2 x 15.2 cm]). The color of the background should be taken directly from the object. This example shows a leaf and the inventory taken from it (figs. 7.10–11). The number of dots in a nonproportional inventory can vary. Obviously the fewer the dots, the more difficult it will be to characterize the overall coloration of the source. Somewhere between ten and twenty is usually enough. No two dots should be the same. Try to match the colors you observe precisely.

14B. Base a composition on tones drawn from the nonproportional inventory.

Examples:
Figs. 7.10–15

Rationale: The nonproportional inventory challenges your ability to represent the innumerable tones of a visual source succinctly. It is a practical way to address complex color sources, particularly those taken from the natural world.

7.10

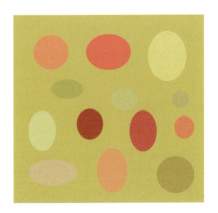

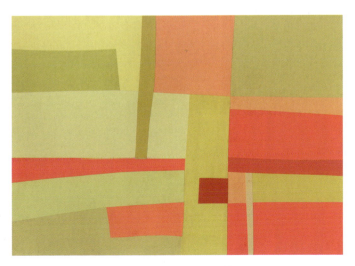

7.11 Nonproportional inventory of fig. 7.10.

7.12 Composition derived from the nonproportional inventory.

In this example (figs. 7.13–15), the student (a textile designer) has transformed a nonproportional color inventory of a seashell into a delicate paper weaving.

7.13

7.14

7.15

COLOR ANALYSIS

The act of description can make us more keenly aware of color content in a work of art or design. Using the terminology with which we are now familiar, we will discuss four examples of contemporary art.

The work of Diane Itter (1946–89) can be seen as a protracted investigation of color and pattern. She produced hundreds of knotted textiles on an intimate scale like the one shown here. This piece (fig. 7.16) deploys progressions of hue and value to create a sense of light and movement. Itter's palette is broad in all structural categories, but her controlled evocation of multidirectional light sources makes it all cohere. The grid seems to be suspended in front of a shifting field of background illumination. Yet in places, where it goes lighter in value, it also appears to be lit from the front.

Itter constructed the piece so that the threads of linen seem to pour out of the design. This outflow of color softens and complements the rigor of the grid structure. Because each particle of color is also a knot, Itter's visual effects are based on optical mixing.

7.16 Diane Itter, *Grid Flicker #1*, 1981, knotted linen, Private Collection.

In illustrating a traditional Japanese children's tale, David Mazzucchelli combines the narrative conventions of the comic book with stylistic aspects of traditional Japanese woodcuts (fig. 7.17). He employs subtle transitions of hue to suggest an underwater world. His choice of line color is inventive, using blue instead of black and two different values of blue to evoke a sense of spatial depth. Mazzucchelli uses color to help tell the story and to create a dream-like atmosphere.

7.17 David Mazzucchelli, *Taro*, 2001, gouache, collection of the artist.

Julia Jacquette often works with images taken from the great flow of photos and illustrations that form the visual detritus of contemporary American culture. Here (fig. 7.18), she combines sixteen images of torsos in wedding dresses, the pattern of the grid playing against the patterned brocade of the gowns. Jacquette has organized the figures in a way that suggests a turning movement within the static format of the grid. The color consists solely of chromatic grays, which she makes interesting by carefully shifting their temperature (and therefore the quality of implied light sources) from square to square.

Also note the shifting background colors. Although just peeking through, the backgrounds help suggest a different time of day within each section and provide enough space to lend credible roundness to the torsos.

7.18 Julia Jacquette, *Wedding Dresses*, 2002, oil on linen.

In her painting *What Color Lament?* (fig. 7.19), Mary Frank varies color saturation to powerful effect. The overall tone of the image is a cool, stony gray. The space suggested by the gray is paradoxical in that it appears alternately to be both atmospheric and solidly flat. The small pictorial vignettes contain multiple views of a wilderness place with a timeless aspect. The light in the painting is not an illustrated light but emanates purely from the color itself. Most of the color is tonal and slips from chromatic grays to muted colors here and there. The only prismatic colors are a yellow, which spreads out into a luminous pastel yellow tint, and a particularly acidic scarlet. Frank's use of pure scarlet is unusual in that it stands out starkly, yet seems bound to the whole by the thrust of an implied narrative. These intense areas of inner light are employed, as in a religious icon, to convey a poignant spirituality.

7.19 Mary Frank, *What Color Lament?*, acrylic and oil on board, 1991–93, acrylic and oil on board, Whitney Museum of American Art, New York.

ASSIGNMENT 15

Observation and Analysis of Color in Context

Using the terminology you have learned in this course, carefully describe some of your favorite examples of art or design. Do the same for some of your own free studies.

Example:

Consider the study on the opposite page. An analysis of fig. 7.20 might begin with four quantitative observations:

1. The hues are limited to a variety of reds that run from crimson to scarlet.

2. The value range is extremely narrow and in a low key.

3. Saturation levels run from a dull chromatic gray up to a rich muted color.

4. The most saturated shape (a curved diamond in scarlet) is placed off-center near some of the dullest tones in the painting. This illuminates it against the tight unity of the monochromatic color scheme. It also stands out because it is the smallest and most distinctive shape. Its curved sides nestle it into the surrounding larger circular shapes.

After describing exactly what you see, you might try a leap into the interpretive: "This study evokes an overall feeling of intimacy and quietude accented by the presence of a muted anomaly in saturation" or "The warmth of the palette is combined with softened geometric shapes in a way that suggests meditation."

Rationale: Verbal description helps to focus our attention on form. By analyzing art objects in this way we come to know them more deeply. Also, the language you have learned to apply to color becomes truly familiar through use. This exercise fosters conceptual clarity and underscores the crucial difference between seeing and noticing.

7.20

FREE STUDIES

In fig. 7.21, analogous hues revolve around yellow-orange. Values extend from the upper middle range in the yellows down to some dark reds and browns. Interestingly, this study is painted over a dark green-brown background that shows through wherever the pigment has been separated by brushstrokes made by a stiff hog's-hair brush. Muted colors dominate and the soft grid structure complements the softly glowing tones.

Fig. 7.22 demonstrates the use of a red color anomaly. The red rectangle is mostly in muted color but contains streaks of pure red near the center. Other colors are blues and greens, with the important exception of the large reddish chromatic gray square in the lower-right quarter. This gray provides a transition between the red and green parts of the design. The artist makes clever use of spatial ambiguity in this cut-paper collage.

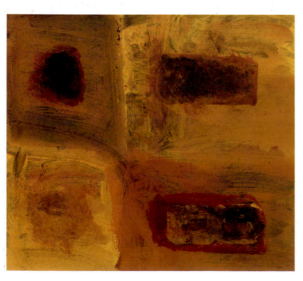

7.21

7.22

In fig. 7.23, contradictions of scale and styles of representation are held together by the strong and varied use of red. All levels of saturation are represented, as is the broadest possible temperature range within a single hue—from scarlet to cool magenta. An electric blue-violet explodes out of the magenta and competes for visual dominance with a large, partially hidden flower. The silhouetted half-figure is dwarfed by the other elements and coaxes us, somewhat illogically, to read the heavy dark rectangles likewise as silhouettes.

This whimsical study (fig. 7.24) suggests a tinker toy interpretation of a classic "Vanitas" still life complete with tabletop, skull, and other symbols of transitory existence. The hue range is broad, but, except for a few accents in muted color, chromatic grays predominate. Light and shadow are evoked (but not clearly described) by numerous tonal variations within the grays.

7.23

7.24

The grid in fig. 7.25 has been painted free-hand to lend it a fragile quality consistent with the delicacy of the design's light overall tonality. In this nearly achromatic gray context, the highly tinted blue and yellow chromatic grays have enough presence to assert their position in the foreground.

This calligraphic study (fig. 7.26) makes good use of subtle variations of saturation within the muted colors, red and green. The flickering lighter marks echo the subtler rhythms of the darker colors and animate the composition. A sense of depth is achieved by overlapping strokes of color in a way that suggests weaving.

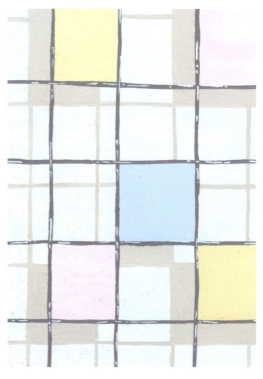

7.25

7.26

Like the preceding example, fig. 7.27 employs a palette of red and green. The result is very different, however. This design is more robust, owing to its strong darks, muscular paint application, and brick-like slabs of color. The saturation range is broad and the colors are rich. The edges of each shape have been carefully varied to enliven the grid. Each shape also has its own individual quality of paint coverage from solid opacity to ruggedly scumbled passages that allow the underpainting to show through.

In fig. 7.28 the artist takes his color cues from small fragments of printed material that appear at the bottom of the study. This printed matter introduces highly saturated accents that reappear more quietly as muted color in the surrounding areas. Beginning with the very pale yellow around the letter "R," warm chromatic grays get progressively darker in a sequence of tones that ends in the red-brown of the background. Paint is applied with a stamping technique.

7.27

7.28

8. THE PSYCHOLOGICAL EXPERIENCE OF COLOR

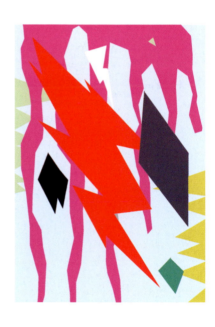

"Pure colors… have in themselves, independently of the objects they serve
to express, a significant action on the feelings of those who look at them."

Henri Matisse

COLOR: SYMBOL OR ANALOGUE?

That color affects the psyche is indisputable. That specific colors directly communicate precise meanings is less certain. It is true that connections have often been made between specific hues and abstractions like loyalty or cowardice. Color symbolism of this kind pervades human history, but varies from culture to culture.

Symbolic color associations require an audience of shared cultural experience. Only such a pre-conditioned group can be expected to comprehend, for example, that blue represents loyalty. The attachment of the color blue to the abstraction "loyalty" is nebulous. "And what blue?" one must ask. Still, most would agree that color conveys something other than its own visible properties. But if not specific meaning, what?

If we substitute the word *experience* for meaning, we may get closer to the way in which color can lend significance to form. Color, when it arouses feeling, tends to do so not as a symbol, but as an analogue. (An analogue is a feasible substitution of one thing for another based on a perceived similarity between the two.)

A good example of this is the warm/cool dichotomy represented in the color wheel. As mentioned previously, people everywhere seem to equate blue, green, and violet with coolness, and red, orange, and yellow with warmth. This association probably has roots in our longstanding physical relationship to ice, shadows, and deep water (coolness), and to fire, sun, and desert (warmth). The spectrum, bisected in this way, provides visual analogues for the physical states of coolness and warmth. The experience of "warm" colors links them to elemental heat sources, but doesn't *literally* refer to them as a symbol would. Color meaning seems to spring from a psychological reaction to physical experience.

The most nearly universal color analogues (such as warm and cool) are probably rooted in human biological needs that are connected with such fundamental attributes as health and survival or pleasure and pain. As diurnal creatures, subdued lighting can evoke strong emotion in us. Without clear vision, we are more vulnerable, and vulnerability provokes apprehension. Conversely, the clear colors of good vision and good weather elevate our sense of safety and wellbeing. The effect of specific color groups can also be reasonably attributed to our physical experiences. But one should refrain from drawing facile conclusions about individual colors from such conjectures. Dark colors, it might be argued, are depressing, while bright orange, which is both warm and clear, lifts us up. But darkness can also be rich, like coffee, and bright orange can seem quite mad. Isolated colors may evoke associations, but only in an unreliable fashion.

Moreover, in art, color is seldom seen in isolation. It is usually found in groupings, linked with subject matter and form that are, themselves, rife with analogies. Shapes, intervals, textures, patterns, qualities of edge, and relative visual density are all features of the abstract language of design that infuse an image with associative qualities apart from that of color. It makes sense, therefore, to discuss the experience of color as an interrelational phenomenon and not as a system of independent symbols.

For example, we may naturally connect free-floating diagonal shapes with instability. If the shapes are combined with sudden dramatic shifts in scale, and if they are jagged, sharp, and seem to be in a state of flux, our visual experience will be akin to excitation, even alarm. The shapes in fig. 8.1 are as just described. Add color that is similarly disjointed and the jarring effect of the design is heightened (fig. 8.2).

The same design colored instead with chromatic grays in a consistent key (fig. 8.3) presents a more complex visual experience. The character of the color ensemble is at odds with that of the design. What was formerly cacophonous is now quieted by a sense of distance. We may even perceive irony in the visual conflict that presents itself. The psychological experience of this composition is clearly altered by changes in its color.

8.1

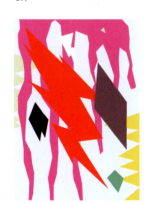

8.2

8.3

Color analogy should be approached in terms of all three color parts—hue, value, and saturation—since all three affect our response. Another important factor is the kind of contrast that colors exhibit in relation to each other. To comprehend this, examine the colored grids at right. (The grid is a stable, passive format that contributes a minimum of visual competition to the colors under consideration.)

The first grid (fig. 8.4) consists of nine prismatic colors of diverse hue and broad contrast in value. The overall effect is lively, fresh, and casual. The color relationships are not subtle.

The grid in fig. 8.5 has the same hue arrangement as fig. 8.4, but all the colors have been tinted by about 50 percent, lowering their saturation levels and softening value contrast. The arrangement still has an upbeat quality, but its greater unity engenders a pensive aspect that is not present in the first version. Overall, it is a gentler rendition of these hues.

In the final grid of this series (fig. 8.6) the same hues are rendered in even more unified middle values of lower saturation. Here the colors are quieter. Value contrast is minimal so it is easier to read the grid as a continuous visual field. Of the three examples, fig. 8.6 seems the most emotionally subdued.

8.4

8.5

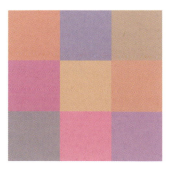

8.6

The next three grids are diverse, each with its own psychological "weather system." The colors in fig. 8.7 are extremely luminous and close in value. Again, the whole visual field is easy to read as a unity. The hues of these subtle colors emerge slowly from the color field and assert themselves fully only after sustained viewing. This palette is airy and delicate and might be associated with fragile qualities like innocence or memory.

The second study (fig. 8.8) has a medium value range which makes the shapes stronger and the grid more visible than in fig. 8.7. Hues are diverse, but appear earthy at these saturation levels. Colors like these can have a dusty, antiquated quality in certain design contexts. They can also suggest natural materials.

The third palette (fig. 8.9) is uniformly dark, but varied in saturation. Hues are not unified and somewhat random in relation to each other. Each color is dense and suggests impenetrability. Despite the brilliance of some of the colors, it is not a lighthearted grouping. But it could be interpreted positively as deeply dark and rich, like jewels in a mineshaft.

8.7

8.8

8.9

Color is used in advertising to make a product look appealing. This baby food ad (fig. 8.10) shows four children happily engaged with the product. It is a multiracial group and the shifting backgrounds, in bright but muted colors, reinforce the idea of multiculturalism. That the background colors are close in value and the portraits are arranged in a grid strikes a note of egalitarianism. The overall experience is pleasantly intimate and inclusive. The color of the ad and its content are perfectly synchronized.

The second ad is for a brand of wine (fig. 8.11). Darkness here connotes richness of flavor. The dark, chiaroscuro treatment, with the fruit seeming to emerge from deep shadow, makes both its succulence and savor evident.

The third example (fig. 8.12) is not an ad, but a title illustration by Rita Endestad for an article centered, as is suggested by the imagery, around island vacations. The illustration has a breezy, almost insouciant aspect in keeping with the subject matter. The images are collaged with considerable freshness to a very simple background of two colors: blue and white. But each hue contains subtle shifts that animate the large color planes while giving us a glimpse of the painting process. The colors are vivid or high key except for a few black shapes. Overall, it is a spirited color ensemble.

8.10

8.11

8.12

In the end, concrete correlations between colors and specific psychological responses are elusive. Much depends on the context, both in form and subject matter. There are also bound to be idiosyncratic associations of color and meaning. But, undeniably, color can communicate, by way of analogy, states of being that add meaning to form.

Connecting an abstraction with a specific group of colors is a species of poetic insight. Poets connect unalike things through simile and metaphor. Such pairings are less arrived at through a process of reasoning than netted by the poet's unconscious mind. Sometimes such analogues are unexpectedly revealing. The connection is rational only after the fact.

Using color to enhance meaning requires a similar kind of imagination. One can, as we have done, compose color groupings and interpret them plausibly in terms of ideas and emotions. But there is no formula for this. You can rely on the integrity and commonality of your own physical experience for a start. After that, it is the quality of your vision as an artist or designer that will lend veracity to your experiments.

8.13

ASSIGNMENT 16

Color Analogue Studies

Select a pair of verbal concepts that are either opposite or are in meaningful contrast with each other. For example: sullen/elated, emotional/rational, old/young. Using a passive format (e.g., a grid of dots on a background, a grid of squares, or any grid-based configuration), make two studies that are different only in their color. Try to make color analogues for each of your concepts.

Examples:
Figs. 8.13 (power) and 8.14 (wisdom)

Rationale: Using the same passive format for each study puts more weight on the role of color. This assignment is an opportunity to put structural understanding in the service of visual communication.

8.14

FREE STUDIES

The illusion of three-dimensionality can be rendered through a consistent depiction of light and shadow. In the block study shown below right (fig. 8.15), the direction of the light is consistent throughout, but progressions in parallel planes suggest a shift in its temperature and strength.

Fig. 8.16 hints at two different light sources, one from above and one from the right. This duality makes the design appear to alternate between two or more spatial interpretations. The gradation of the planes conveys a subtle impression of light in motion.

The four triangular shapes in the center of fig. 8.17 read, somewhat paradoxically, as a light-struck pyramid seen from above. But the facets of the form seem to slip away at the edges and flatten out. Notice that the lines emanating from the point of the "pyramid" end precisely at the corner of the design in only one instance. Line and color are used here to tease the viewer into a contradictory spatial interpretation.

8.15

8.16

8.17

9. COLOR STUDIES ON THE COMPUTER

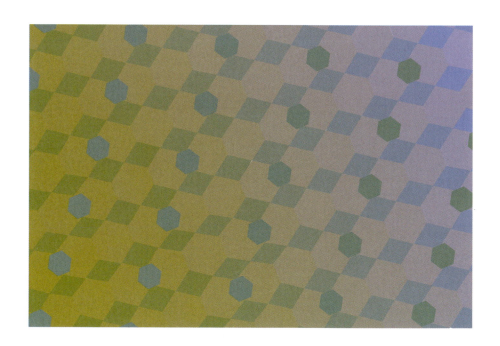

"To attend to color, then, is, in part, to attend to the limits of language. It is to try to imagine, often through the medium of language, what a world without language might be like."

David Batchelor

In the past decade, the development of digital technology has touched nearly every aspect of design production, and design practice has undergone a technical revolution. Even artists who don't use the computer directly, e.g., painters and weavers, have found it useful in the documentation and dissemination of their work.

Since 1995 we have used the computer in this course to support handmade studies. To be sure, the hand-painted assignments stand up well by themselves; computer work is not necessary to the curriculum. Moreover, to do the studies on computer alone would be insufficient. But we have found that following handmade studies with digital versions of the same assignments can reinforce understanding.

Software and Output

The program we use, and the one best suited to doing color studies, is Adobe Illustrator. Illustrator has several major advantages over other software:

1. It produces documents that require very little memory to store.

2. Its images are vector-based and resolution-independent. This means that they can be printed at any size without depreciation in clarity or ragged edges.

3. Color changes can be viewed in context and can be made simultaneously in numerous objects.

4. The bounding lines that surround shapes when they are highlighted can be hidden so that one can observe the interaction of one color directly with another.

5. Work can be done in layers, so parts of a composition can be altered in isolation from other parts.

The color work for this course requires only a rudimentary understanding of the program. Basically all one needs to know is how to make simple geometric shapes and how to color them with precision.

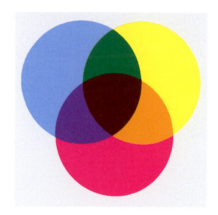

9.1 The overlapping of the light primaries (RGB) produces a white light.

We print all digital studies on an ink-jet color printer using matte 8½ x 11 inch (21.6 x 27.9 cm) heavyweight paper. Documents are usually comparable in dimension to the painted version or slightly smaller. Generally, they are no smaller than 5 inches (12.7 cm) in either direction.

RGB and CMYK

In digital programs, two different sets of primary colors come into play: RGB and CMYK. RGB stands for red, green, and blue. These are the additive primary colors used in colored light applications, e.g., video technology. The colors on the monitor are made by combining these light primaries. When red, green, and blue are all present, a white light results (fig. 9.1).

Digital output, i.e., printed versions of a digital document, is made with the subtractive primaries. In painting, these are red, yellow, and blue. Printing processes use translucent inks instead of paint. In printing inks the primaries are CMY or cyan (blue), magenta (red), and yellow. In both commercial and ink-jet printing, colors are overlapped and mixed optically.

Intermixing the subtractive primaries makes a dark, muddy-brown color, not a true black (fig. 9.2). Therefore, in printing K (meaning black) is added to the triad. The addition of black also increases tonal possibilities.

The range of colors available in any system is called a GAMUT. Fig. 9.3 is an approximation of three different color gamuts. The visible spectrum is indicated by the entire shape, the light gamut (RGB) is delineated by the pink triangle, and the pigment gamut (CMYK) is bounded by the yellow line.

Each color gamut is limited. Printed color (CMYK) has a narrower range than light color (RGB) and both are narrower than the range of human vision. The colors you see on the monitor may extend beyond the gamut of the printer. Also bear in mind that highly saturated colors will appear more vivid on the monitor than in print. In print, however, subtle color relationships are much easier to read and nuances within subdued colors are also more perceptible.

9.2 Intermixing the pigment primaries (CMY) produces a dark brown.

9.3 This diagram shows three different color gamuts: CMYK, RGB, and the visible spectrum.

In Illustrator, as in other programs, you have the option of using RGB or CMYK sliders. Choose CMYK. Your color training is with subtractive color and the CMYK sliders allow you to use color in a way that mimics the mixing of pigments surprisingly well. Combining red (magenta) and blue (cyan) will, as with paint, make violet. And, as with paint, adding black (K) will create a shade of any hue.

Pushing sliders is a somewhat abstract activity compared to the sensual experience of moving paint with a brush, and some digital color functions seem idiosyncratic. For example, on the monitor colors are tinted, not by adding white, but by moving the sliders to the left. The effect is similar to a mixed tint: the color becomes both lighter and duller, but the reasoning is a bit different. As it turns out, the differences between computer and hand mixing can actually make us think about the structure of color in a fresh way. Repeating assignments digitally offers a new view of color principles.

MIXING COLORS WITH SLIDERS

Hue

In CMYK, pure cyan, yellow, and magenta are the only one-part prismatic hues (black is not a hue). All other prismatic hues can be obtained with two sliders. When three primary sliders (CMY) are used, the result is a tone. (Tints can be produced with one, two, or three sliders. A shade requires adding the K slider.)

Value

In any color, values are determined by moving the slider. Moving it to the left lightens the value of a color, moving it to the right darkens it. In Illustrator, with two- and three-part colors, moving one slider as you hold the shift key will also move the others while maintaining their relative hue proportions. Thus the value of the color is altered without changing its hue.

Saturation

As with pigment, saturation can be conceived on three levels: prismatic colors, muted colors, and chromatic grays. We are going to examine saturation with the aid of diagrams roughly similar to color sliders in Illustrator and other programs. The numbers on the right are numerical percentages of color content for each slider, and the square at the bottom is the color itself.

The first diagram (fig. 9.4) shows a typical one-part hue at full saturation. Although it seems reasonable to define prismatic hues only at 100 percent, in actuality one-part hues appear prismatic as far down as 90 percent. (It is very important to remember that screen color, especially cyan, looks lighter and richer on screen than it will when printed.)

In fig. 9.5 we see a "tint" of cyan at 50 percent. In saturation, this is a muted color. Moving the slider to the left is like adding white; the value lightens but the hue remains the same.

A more highly tinted version of cyan is shown in fig. 9.6. At 15 percent, the color is a chromatic gray. At what point on the slider a tint changes from a muted color to a chromatic gray is a matter for you to determine. Be prepared for the printed version to surprise you.

In one-part hues, only tints of pure color are possible. A dark or middle value cannot be produced in chromatic gray.

Colors made of two parts are essentially the same as one-part colors. At full saturation they are prismatic. They can be tinted, but, as with one-part hues, they cannot produce dark- or middle-value colors in chromatic gray. With practice, you will be able to distinguish saturation levels within the tints. As previously mentioned, moving one slider while holding the shift key down will move both colors simultaneously and *unequally* to maintain the original hue proportions.

9.4

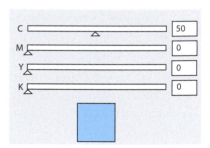

9.5

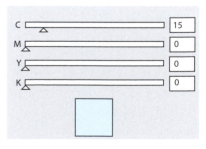

9.6

Three-part colors are, in important respects, unlike one- and two-part hues. We will begin by looking at a mid-value chromatic gray with all three hues poised at 50 percent (fig. 9.7). Theoretically, one would expect an equal balance of three hues to be achromatic, i.e., having no discernible hue or temperature. In actuality, the color is a warm, somewhat dusty brown. Its hue originates somewhere between yellow and yellow-orange. (A more truly achromatic gray can be achieved using three colors with a bit less yellow. For an added challenge, try to match 50 percent K—truly achromatic— with a three-part color. Test the color match in printed form.)

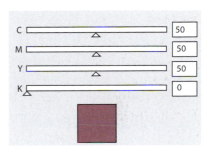

9.7

Holding the shift key while moving sliders will alter the value of this gray without changing its hue identity (temperature) (fig. 9.8). All tints made from this combination of hue percentages will be chromatic gray. With three-part color, one can make chromatic grays of any value.

In three-part colors, it is easy to make chromatic grays and muted colors by starting with all three arrows aligned vertically. If, for example, we start with the arrows aligned at 50 percent (as in fig. 9.7) we can create a bluish chromatic gray by adding cyan and subtracting both magenta and yellow (fig. 9.9).

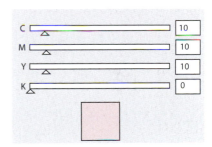

9.8

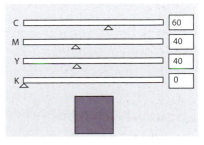

9.9

Moving c more to the right and MY to the left produces a mid-tone muted color in blue (fig. 9.10). This procedure can be repeated with any hue at any level of value.

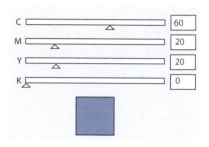

9.10

Using the Black Slider

The K slider makes it very easy to darken and dull color with the addition of black. True black can be useful in its own right. But, as we have learned, achromatic grays like those produced on the K slider are devoid of inherent light. They have no hue or saturation (except in certain specialized contexts).

Try not to use more than 10 percent black in any color while making these studies!

Creating a Color Reference Chart

In order to gain a frame of reference for color transitions from screen to print, it is a good idea to make a color chart like the one shown on the opposite page (fig. 9.11). In this particular grid the primary and secondary triads are alternated in sequence from left to right.

While the hue arrangement remains constant as the grid moves south, each horizontal row shows the original hues in variation. Colors in row 1 are prismatic. Rows 2 and 3 are middle-value and light tints of the original colors. As for saturation levels, those in row 2 are muted colors and those in row 3 chromatic grays. Rows 4, 5, and 6 consist of three-part colors. Row 4 is close to row 3 in value, but another hue has been added, making these tones a little dustier, not quite so lucid as those in 3. Both rows 5 and 6 are mostly muted colors with a few chromatic grays.

The purpose of making such a chart is to have a reference at hand for the color you are manufacturing on the screen. Make sure you print the chart out on the same ink-jet printer that you intend to use in printing your studies. Design a similar grid organizing color groups according to your own logic. (It can be more extensive than the one shown here.)

With practice, you will be able to look at a printed color and guess with surprising accuracy its numbers in CMYK.

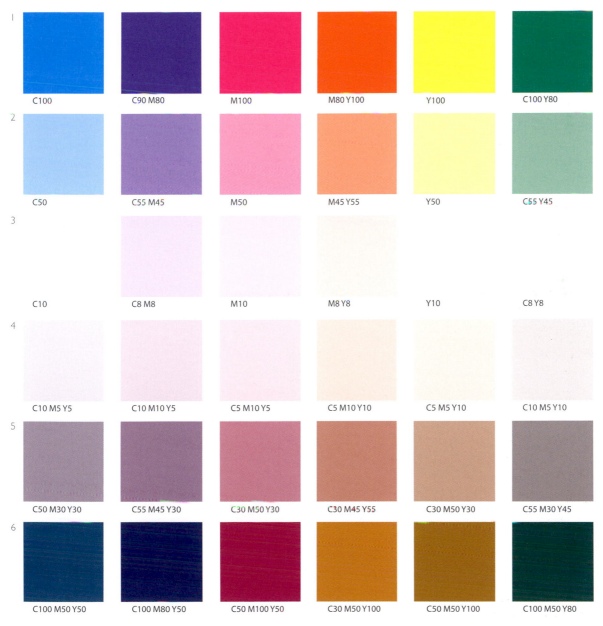

1 C100 C90 M80 M100 M80 Y100 Y100 C100 Y80

2 C50 C55 M45 M50 M45 Y55 Y50 C55 Y45

3 C10 C8 M8 M10 M8 Y8 Y10 C8 Y8

4 C10 M5 Y5 C10 M10 Y5 C5 M10 Y5 C5 M10 Y10 C5 M5 Y10 C10 M5 Y10

5 C50 M30 Y30 C55 M45 Y30 C30 M50 Y30 C30 M45 Y55 C30 M50 Y30 C55 M30 Y45

6 C100 M50 Y50 C100 M80 Y50 C50 M100 Y50 C30 M50 Y100 C50 M50 Y100 C100 M50 Y80

9.11

MAKING COLOR STUDIES

Not counting free studies, there are sixteen assignments in this course. Of these, six do not make sense on the computer. These are the retinal studies, the limited-palette dot studies, those that contrast two primary palettes, those that explore the altered palette, and assignment 15 (color analysis). The other ten can be done profitably as digital studies.

We will look at digital examples of assignments 1, 2, 3, 4, 5, 6, 7, 9, 14, and 16. For descriptions of the assignments, refer back to the chapters in which they are introduced. The page number of each description will appear in parenthesis next to the assignment number.

As with the painted studies, always try to maintain stylistic unity within a group of compositions.

ASSIGNMENT 1

Chromatic Gray Studies (page 46)

Examples:
Figs. 9.12–13

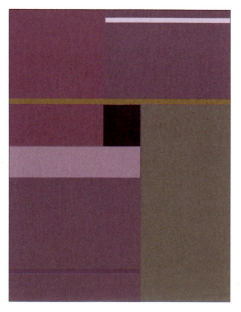

9.12

9.13

ASSIGNMENT 2

Muted Color Studies (page 50)

Examples:
Figs. 9.14–15

9.14

9.15

ASSIGNMENT 3

Prismatic Studies (page 52)

Examples:
Figs. 9.16–17

9.16

9.17

ASSIGNMENT 4

Combined Saturation Studies (page 53)

Examples:
Figs. 9.18–19

9.18

9.19

ASSIGNMENT 5

Interaction Studies (page 70)

Examples:
Figs. 9.20–22

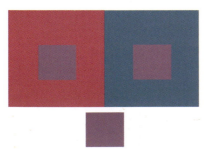

9.20 One color as two.

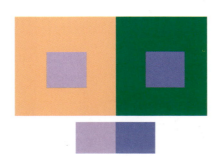

9.21 Two colors as one.

The computer facilitates the exploration of color interaction. When squares are selected on the monitor in Illustrator, they are bounded by blue outlines. By pressing command-h you can hide these outlines while squares are selected. This enables you to see the interaction of colors as they touch each other directly. You can change colors in small numerical increments and witness the subtle effects of your actions each step of the way.

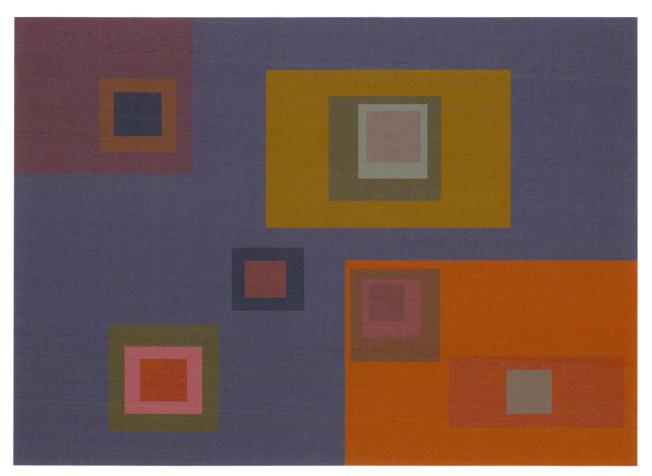

9.22

ASSIGNMENT 6

Progression Studies (page 84)

Examples:
Figs. 9.23–28

Progression studies are particularly suited to the computer. But it is imperative that you resist overly elaborate configurations. For many students the temptation to create labyrinthine designs overwhelms the goal of the assignment. Your focus should be on even, integrated progression systems that contain a lucid inner light. Think of them as graphic designs meant to communicate the idea of color progression.

For these studies it is advisable to work in layers. Avoid gradation functions; each separate shape should be a flat color.

As an extra challenge, try a composition that combines progression with interaction. Repeat a color throughout the design, making it appear to change by virtue of its transitional color environment. (The repeated hexagons in fig. 9.26 and the light horizontal stripes in fig. 9.28 are constant elements. The same color [numerically] is repeated throughout each design while it appears to change.)

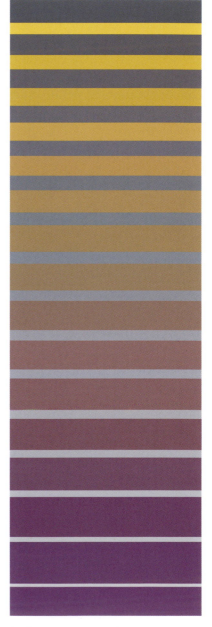

9.23

9.24

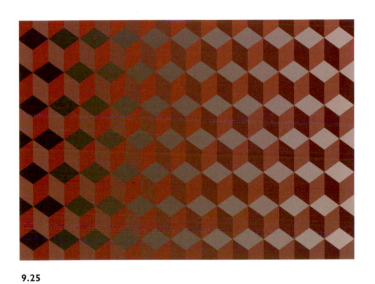

9.25

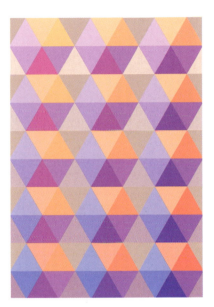

9.26

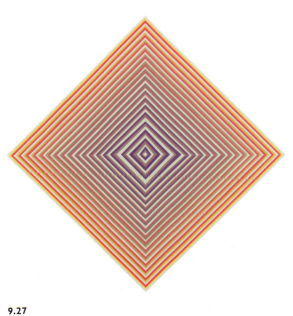

9.27

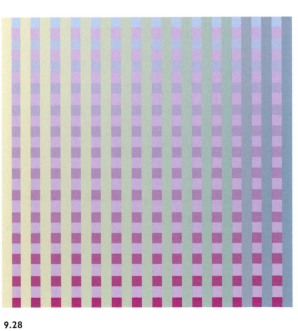

9.28

ASSIGNMENT 7

Transparency Studies (page 87)

Examples:
Figs. 9.29–30

The command-h function is also useful in creating transparencies where seeing color against color is invaluable. In the median transparency (fig. 9.29), a good test for hue accuracy in the overlapping color is to isolate each wing as shown below. The middle color should look greenish against the orange tint and slightly orange against the green. The values should also appear reversed.

The same is true of the hue relationships in dark transparency. In the example below (fig. 9.30), the middle color should look blue against the orange and orange against the blue. The value relationships will, however, remain the same. The middle color is darker than both wings.

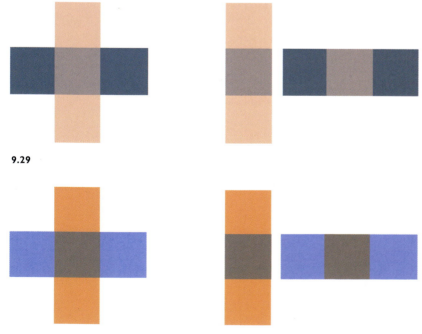

9.29

9.30

9.31

ASSIGNMENT 12

Anomaly and Bridge Tones (page 109)

Example:
Fig. 9.31

Because objects can be easily replicated on the computer, this assignment is particularly suited to a digital treatment.

ASSIGNMENT 13

A Proportional Inventory (page 115)

Example:
Fig. 9.32

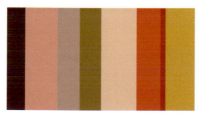

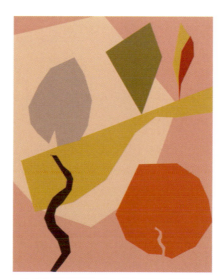

9.32

ASSIGNMENT 14

A Nonproportional Inventory (page 117)

Example:
Fig. 9.33

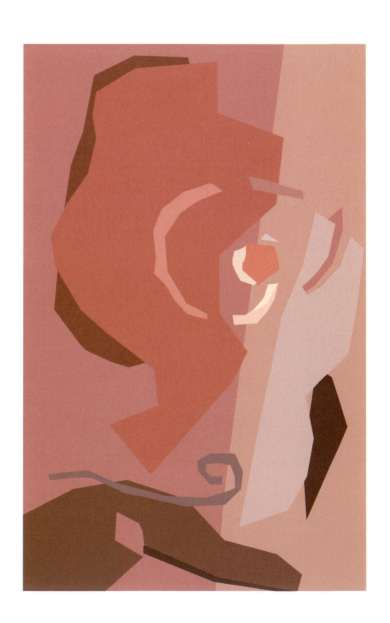

9.33

ASSIGNMENT 16

Color Analogue Study (page 134)

Example:
Figs. 9.34 (passion) and 9.35 (intellect)

9.34

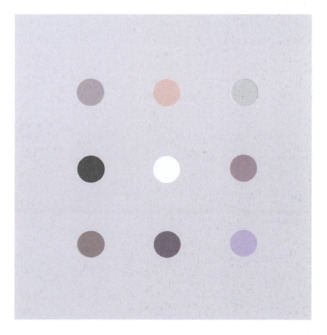

9.35

ILLUSTRATED GLOSSARY

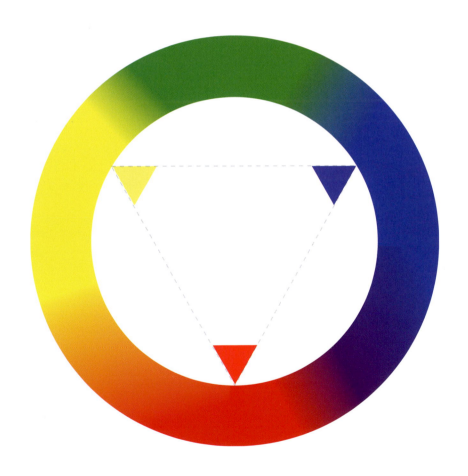

ACHROMATIC GRAYS

Grays that are created by mixing black and white. Achromatic grays have no evident coloration when seen against a white background. Black and white are also achromatic.

ADDITIVE COLOR

Color as seen in light. Additive color primaries are red, green, and blue-violet; when they are combined, the result is white light.

AFTERIMAGE

A common optical effect in which an additional color seems to appear at the edge of an observed color.

ANALOGOUS HUES

Hues that lie adjacent to each other on the color wheel.

ANOMALY

An irregularity; a deviation from a norm. An anomalous color is one that breaks sharply with the dominant tonal quality established by a group of colors.

Light blue is an anomaly in this image.

BRIDGE TONES

Tones, tints, or shades that combine qualities of two distinctly different colors and act to soften those differences when placed near them in a composition.

CHROMATIC DARKS

Very dark chromatic grays that have discernible temperature.

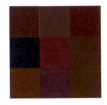

CHROMATIC GRAYS

Subtle colors that result from considerably lowering the saturation level of prismatic colors. Chromatic grays weakly exhibit the distinguishing quality of the hue family to which they belong.

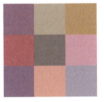

COLOR WHEEL

A circular depiction of various colors and their relationships traditionally used to illustrate aspects of a particular color theory. The wheel used in this book is divided into twelve major hue divisions that include primary, secondary, and tertiary hues. Primary colors are subdivided into pairs of co-primaries. In addition, the circle is divided into four concentric rings that depict four levels of saturation: prismatic color, muted color, chromatic gray, and achromatic gray.

COMPLEMENTARY HUES

Hues that lie directly opposite each other on the color wheel.

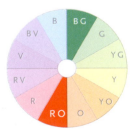

The complements blue-green and red-orange.

CO-PRIMARIES

The result of the subdivision of the (subtractive) primary triad into three pairs consisting of cool and warm versions of each hue. The use of co-primaries greatly extends the potential range of mixed colors.

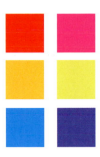

DARK TRANSPARENCY

An illusion of transparency where the color of the overlapping area is darker in value than both colors that appear to overlap. The hue in a dark transparency blends the hues of the two parent colors equally.

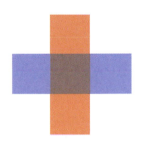

EARTH TONE PRIMARY TRIAD

A primary triad of chromatic grays (so called because of their resemblance to pigments found in nature, e.g., ochers and umbers).

GAMUT

In computer terminology, the range of hues available to a particular mode, e.g., RGB or CMYK.

GRAYSCALE

A graduated representation of the value continuum broken down into a finite number of steps, usually ten, eleven, or twelve achromatic grays.

HIGH KEY

What an image is said to be when the colors in it are predominantly light in value.

HUE

The name given to a color to describe its location on the color spectrum based upon its wavelength.

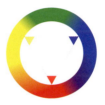

The primary triad located on the color spectrum.

HUE CONTINUUM

A graphic representation of the full color spectrum from red to violet.

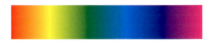

INHERENT LIGHT

The light that seems to glow from within a color.

LOW KEY

What an image is said to be when the colors in it are predominantly dark in value.

LUMINOSITY

The amount of light reflected from the surface of a color. Value is a measure of luminosity.

The center color is more luminous than the outer one.

MEDIAN TRANSPARENCY

An illusion of transparency where the value of the color at the overlap is halfway between that of the two parent colors. The hue of the overlapping area blends the hues of the two overlying colors equally.

MIDDLE KEY

What an image is said to be when the colors in it are predominantly medium in value.

MONOCHROMATIC

A color scheme based on one hue. Monochromatic schemes can include a range of values and saturation levels and may also stretch the definition of one hue to include several different versions of it. (A monochromatic scheme based on blue might include both Prussian and ultramarine blues.)

MUTED COLOR

Rich but softened colors that reside on our color wheel between prismatic color and chromatic gray.

NONPROPORTIONAL COLOR INVENTORY

A graphic rendering of specific colors observed in an object.

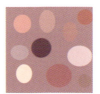

OPTICAL MIXING

This occurs when small color fragments are organized in a tight pattern, appear to fuse, and, from a distance, appear as a single mixed color. Often seen in textile art and mosaics, optical mixing is facilitated by the effects of simultaneous contrast. Most commonly, printed images rely on the optical mixing of myriad tiny dots of color.

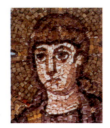

See fig. 4.15.

OVERTONES

A term borrowed from music to describe the secondary hue "bias" of a primary color. For example, alizarin crimson is a red that leans toward violet, while scarlet is a red that has an orange bias. An awareness of overtones is particularly helpful when mixing color.

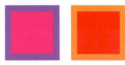

A representation of crimson and scarlet surrounded by their dominant overtones.

PRIMARY TRIAD

The primary triad is so called because, theoretically, all other colors can be mixed from it. In subtractive color the primary triad is composed of red, yellow, and blue, which are equidistant from each other on the color wheel. (In printing ink and on the computer screen, the subtractive primary triad is cyan, magenta, and yellow.)

PRISMATIC COLORS

Pure hues that represent the colors of the color spectrum at their highest saturation level. While these are theoretically infinite in number, our color wheel distributes them evenly into twelve major hues.

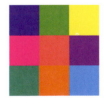

PROPORTIONAL COLOR INVENTORY

A graphic representation of the exact colors and their proportions in an observed object.

RETINAL PAINTING

A term coined by Harriet Schorr in reference to painting from observation in a manner emphasizing the faithful transcription of colored shapes as they appear on the retina of the eye. An outgrowth of Impressionism, this method favors accurate color rendering over drawing to describe form.

SATURATION

Sometimes also called intensity or chroma, saturation refers to the relative purity of hue present in a color. A highly saturated color vividly shows a strong presence of hue; conversely, low saturation refers to a weak hue presence.

The center red is more saturated than the one that surrounds it.

SATURATION CONTINUUM

A graphic representation of the infinite gradations of saturation that exist between any two complementary colors.

SECONDARY TRIAD

In subtractive color, orange, green, and violet. They are called secondary because each can be made by combining two primaries: green = yellow + blue; orange = red + yellow; and violet = blue + red.

A star showing the relative positions of the primary and secondary triads.

SHADE

The result of mixing a color with black.

SIMULTANEOUS CONTRAST

The effect two neighboring colors have upon each other as their afterimages interact along a shared border.

SPECTRUM

Colors as cast upon a wall by a prism, or as seen in a rainbow in the form of pure colored light.

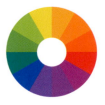

SUBTRACTIVE COLOR

Color seen in pigment as the result of reflected light. Subtractive color primaries are red, yellow, and blue, and, when they are combined, they produce a dark tone that approaches black.

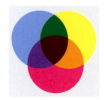

SUCCESSIVE CONTRAST

The name for the visual phenomenon that creates complementary afterimages of a color after gazing at it for a brief but sustained period of time.

Stare at the red circle, then look into the empty box and see a blue-green circle appear.

TERTIARY COLORS

Also called intermediate colors: yellow-orange, yellow-green, red-violet, red-orange, blue-green, and blue-violet. Each combines a primary color with a secondary color.

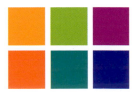

TINT

The result of mixing a color with white.

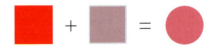

TONE

Made by mixing gray (either chromatic or achromatic) with a color. Tone can also have a more general meaning. The term is sometimes applied to all colors achieved by admixture including tints and shades.

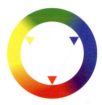

TRIADIC HUES

Color relationships based on any three equidistant hues as shown on the color wheel.

VALUE

The relative quality of lightness or darkness in a color. The only structural aspect of color visible in a black and white photograph.

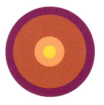

Colors get darker in value as they move out from the center.

VALUE CONTINUUM

A graphic representation that suggests the infinite grays that exist between black and white.

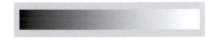

BIBLIOGRAPHY

Albers, Josef. *Interaction of Color*. New Haven, Conn.: Yale University Press, 1963.

Arnheim, Rudolf. *Art and Visual Perception*. Berkeley, Ca.: University of California, 1965.

Batchelor, David. *Chromophobia*. London: Reaktion Books, 2000.

Birren, Faber. *Principles of Color*. New York, N.Y.: Van Nostrand Reinhold Company, 1969.

Bloomer, Carolyn M. *Principles of Visual Perception*, New York, N.Y.: Design Press, 1990.

Chipp, Hershel B. *Theories of Modern Art*. Berkeley, Ca.: University of California, 1968.

Ferris, William. *Local Color: A Sense of Place in Folk Art*. New York, N.Y.: Anchor Books, 1992.

Flam, Jack. *Matisse on Art*. New York, N.Y.: E.P. Dutton, 1978.

Gage, John. *Color and Culture: Practice and Meaning from Antiquity to Abstraction*. Boston, Ma.: Bulfinch Press, 1993.

Goethe, J.W. *Theory of Colors*. Cambridge, Mass.: MIT Press, 1970.

Haftman, Werner. *The Mind and Work of Paul Klee*. New York, N.Y.: Praeger, 1967.

Itten, Johannes. *The Art of Color*. Translated by Ernst van Haagen. New York, N.Y.: Van Nostrand Reinhold Company, 1973.

Kandinsky, Wassily. *Concerning the Spiritual in Art*. Translated by Sadler. New York, N.Y.: Dover Publications, 1977.

Muncell, A.H. *A Color Notation: An Illustrated System Defining All Colors and Their Relations by Measured Scales of Hue, Value, and Chroma*. Baltimore, Md.: Munsell Color Company, 1905.

Newton, Sir Isaac. *Opticks, or a Treatise of the Reflections, Inflections & Colours of Light* (1704). 4th ed. New York, N.Y.: Dover Publications, 1952.

Ostwald, Wilhelm. *The Color Primer*. Edited by Faber Birren. New York, N.Y.: Van Nostrand Reinhold Company, 1969.

Rood, Ogden N. *Colour: A Textbook of Modern Chromatics*. London: Kegan Paul, Trench, Trubner & Co. Ltd., 1904.

Shorr, Harriet. *The Artist's Eye*. New York, N.Y.: Watson-Guptill Publications, 1990.

Sloane, Patricia. *The Visual Nature of Color*. New York, N.Y.: Design Press, 1989.

Tufte, Edward R. *Envisioning Information*. Cheshire, Conn.: Graphis Press, 1990.

Van Gogh, Vincent. *The Letters of Vincent van Gogh*. Boston, Mass.: New York Graphic Society, 1981.

Wollheim, Richard. *On Art and the Mind*. Cambridge, Mass.: Harvard University Press, 1974.

ACKNOWLEDGEMENTS

The Rhode Island School of Design, and especially my colleagues in the graphic design department, provided me with the freedom and opportunity to develop and refine this curriculum over many semesters. I particularly want to thank my colleague Douglass Scott for introducing this project to Lee Greenfield at Laurence King Publishing.

I would also like to recognize the influence of my teachers Richard Lazzaro and Gus Sermas who, by instruction and example, ignited my interest in color. Thanks too to my colleague William Itter, who was my mentor in my first teaching position at Indiana University and who taught me about learning through teaching.

I am fortunate to have many good friends who have contributed in a variety of ways to the fruition of this project. John Anderson, Mary Frank, David Frazer, Judith James, Michael James, Mary Catherine Lamb, Margaret Lewis, Richmond Lewis, Tom McAnulty, David Mazzucchelli, Martin and Jean Puryear, and Grace Wapner have all followed this book through its many stages and offered encouragement precisely when needed. I am especially grateful to two scholarly friends: George Roeder, who planted the seed for this project back in 1991; and Dr. John Stephen Crawford, who brought the role of color in art history to life for me while at the University of Delaware.

Among my many students were a few who contributed significantly to this effort. Alice Chung, Jennifer Maloney, Lydia Neuman, David Sieren, and Cynthia Winings helped proofread text and put together proposal mock-ups. I'm also indebted to my friends Kate DeCarvalho and Sophie Kelle at Pi Design for their help and useful critique of the book design.

Many thanks to Robert Shore for his intelligent editing, to Sally Nicholls for her assistance in gathering the pictures, to Judy Rasmussen for her vigilance on the color reproduction, and to Lee Greenfield for her patience and kind support throughout the publishing process. I would also like to acknowledge the reviewers whose careful reading of this manuscript helped me improve the text.

Finally, I'd like to thank my students who inspired this book and whose beautiful work graces its pages.

CREDITS

FRONTISPIECE Photo by David Caras.

PART ONE 1.1 Chester Dale Collection, Image © 2003 Board of Trustees, National Gallery of Art, Washington. 1.2 Photo © Paul M.R. Maeyaert.

PART TWO 2.2 Photo: Smithsonian American Art Museum/Art Resource/Scala, Florence. 2.5 Photo: The Bridgeman Art Library. 2.6 and 2.15 © Estate of Philip Guston. Photo: © Tate, London 2003. 2.7 and 2.16 © 1998 Kate Rothko Prizel & Christopher Rothko/DACS 2004. Photo: Art Resource, NY. 2.11 © David Hockney. Photo: © Tate, London 2003. 2.31 Photo: The Newark Museum/Art Resource/Scala, Florence. 2.39 Akira Yoshimura. 2.40 Tim Ratanapreukskul. 2.41 © ARS, NY and DACS, London 2004. Photo: Art Resource/Scala, Florence. 2.42 Photo courtesy McKee Gallery, N.Y. 2.43 Photo: Werner Forman Archive. 2.46 © ARS, NY and DACS London 2004. Photo: Art Resource/Scala, Florence.

PART THREE 3.2–5 Chelsea Mackall. 3.6 Ali Asfour. 3.7 Nemyr Canals. 3.8 Calvin Burton. 3.11 Amanda Poray. 3.12 Charles Day. 3.13 Cynthia Wilson. 3.16 Shani Tow. 3.19 Photo: The Museum of Modern Art, New York/Scala, Florence. 3.20 Lila Wells. 3.21 John Cole. 3.22 Olivia Kim. 3.23 William Whittaker. 3.24 © DACS 2004. Photo: The Museum of Modern Art, New York/Scala, Florence. 3.25 Satoka Kawakita. 3.26–27 unknown. 3.28–29 Nathalie Shepherd. 3.30 Laleh Khorraman. 3.31 Kimberly Moody. 3.32 Mason Wiest. 3.33–34 Matthew Palen. 3.35–38 Anna Maka. 3.39–42 Jennifer Boyle. 3.43–46 Vie Panyarachun. 3.47–50 Leslie Johnson.

PART FOUR 4.15 Photo: Scala, Florence—courtesy of the Ministero Beni e Att. Culurali. 4.16 Photo: Giraudon/The Bridgeman Art Library. 4.31 Kate Decarvalho. 4.32 Valerie Britton. 4.33 Sophie Kelle. 4.34 Photo: Werner Forman Archive. 4.36 Photo: V&A Picture Library. 4.37 Photo: Giraudon/Bridgeman Art Library. 4.38 Dori Smith. 4.39 Lise Anderson. 4.40 Sara Yap. 4.41 Ines Hilda. 4.42 Christopher Nagle. 4.43 Alexis Mahon.

PART FIVE 5.11 Alice Chung. 5.12 Peggy Lo. 5.13 Ilivia Yudrin. 5.14 unknown. 5.15 Matthew Chase. 5.16 Kimberly Moody. 5.17 Leslie Jones. 5.18 unknown. 5.19 Photo: Scala, Florence. 5.21 Photo: © RMN—Hervé Lewandowski. 5.22–24 Matthew Demeis. 5.25 Lisa Fisher. 5.26 Kristen Chappa. 5.27 Annie Shen. 5.28 Photo: Smithsonian American Art Museum/Art Resource/Scala, Florence. 5.36 Jehoon Ryee. 5.37 Paul Lin. 5.40 Amy Lombardo. 5.41 unknown. 5.42 Brendan Jackson. 5.47–50 Nathalie Shepherd. 5.51 Jeffrey Grant. 5.52 Sebastian Blank. 5.53 Marc Handelman. 5.54 Christina Grosso. 5.55 Joanne Rumsey. 5.56 Anna-Marie Schuleit. 5.57 Courtesy Private Collection and Artemis Greenberg Van Doren Gallery. 5.59 Courtesy Private Collection and Artemis Greenberg Van Doren Gallery. Photo: Courtesy of Knoedler & Company. New York. 5.60 Alice Chung. 5.61 Christopher Murphy. 5.62 Fahad Razzouqi. 5.63 Emily Joyce. 5.64 Jin Kano. 5.65 Kim West. 5.66 Abby Washburn. 5.67 John Devylder. 5.68 Susan Chiodini.

PART SIX 6.10 John Devylder. 6.11 Alejandro Ortis. 6.14 Danielle Galvin. 6.15 Alice Chung. 6.18, 6.22 Lynette Lorenzo. 6.21, 6.23 Nicholas Felton. 6.36–38 Marie O'Conner. 6.39 Sara Osten. 6.40 Maria O'Callahan. 6.41 Courtney Kincaid. 6.42 Warren Bennett. 6.43 Christine Adolph. 6.44 Mary Sullivan.

PART SEVEN 7.6–7 Marcy Hudson. 7.1 Photo: V&A Picture Library. 7.2 Courtesy Howard Hodgkin. 7.5 Photo: © RMN—Harry Bréjat. 7.11–12 Todd Fidelman. 7.14–15 Christine Adolph. 7.19 Courtesy DC Moore Gallery, New York. 7.20 Theresa Tam. 7.21 Matthew Palin. 7.22 Richard Martinez. 7.23 Sondra Gibson. 7.24 Gregory Ricci. 7.25 Lauren Fisher. 7.26 Kerry Hagy. 7.27 John Anderson. 7.28 Isaac Tobin.

PART EIGHT 8.15 Jeeyoon Yoo. 8.16 Elizabeth Eddins. 8.17 Lise Perreault.

PART NINE 9.12–13 Kristin Boyle. 9.14–15 Shani Tow. 9.16–17 Smanda Poray. 9.18–19 Alex Ching. 9.22 Marisa Tesauro. 9.23 Aparna Shona Dutta. 9.24 Jin Joon. 9.25 David Sieren. 9.26 Elizabeth Eddins. 9.27 Jin Joon. 9.28 Jae Young Yoon. 9.31 Eunice Kang.

INDEX